love in Asian art & culture

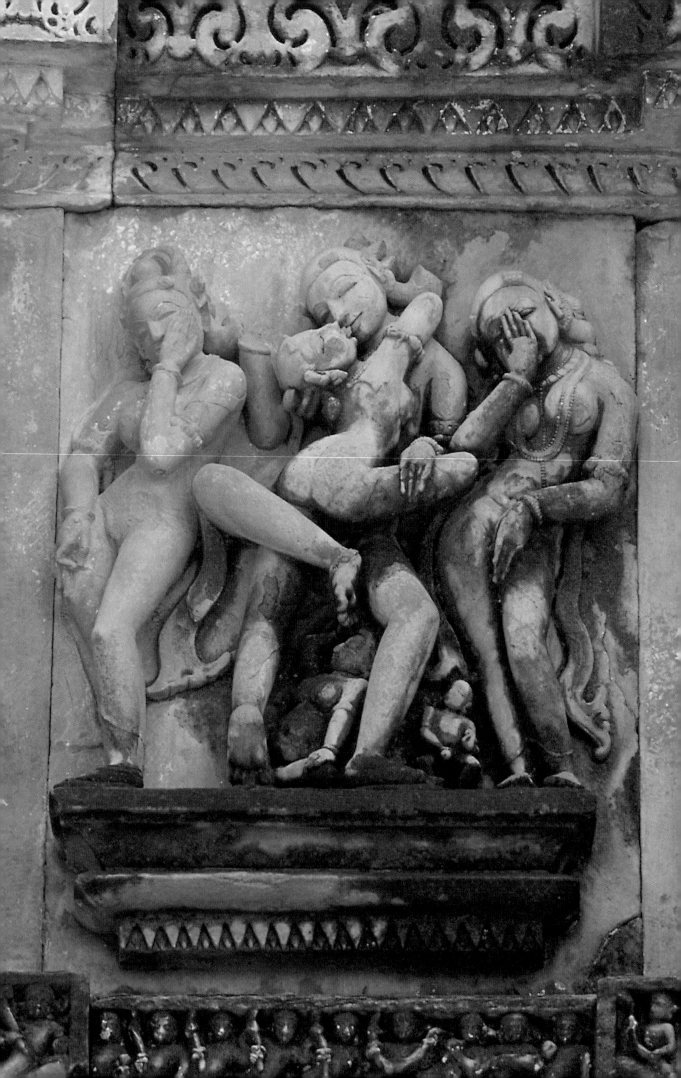

love

in Asian art & culture

ARTHUR M. SACKLER GALLERY, SMITHSONIAN INSTITUTION

in association with the

UNIVERSITY OF WASHINGTON PRESS, SEATTLE AND LONDON

Copyright © 1998 by Smithsonian Institution
All rights reserved
Published by the Arthur M. Sackler Gallery,
Smithsonian Institution, Washington, D.C.
in association with the
University of Washington Press, Seattle and London.

Editor: Karen Sagstetter
Designer: Carol Beehler
Typeset in Minion and Frutiger
Printed in Hong Kong

Cover: Detail, *She desired to triumph,* from part 12,
"Ecstatic Krishna," of *Gita Govinda,* India, state of
Kangra, Punjab Hills, ca. 1820–25. Opaque water-
color and gold on paper, 28.2 x 36.6 cm. Collection
of Anupam and Rajika Puri. Photograph by John
Tsantes.

Frontispiece: Stone panel from Kandariya Mahadeva
temple, dedicated to Shiva, Khajuraho, India, 1025.
Photograph by Neil Greentree.

Library of Congress Cataloging-in-Publication Data
Love in Asian art and culture.
p. cm.—(Asian art & culture)
Includes bibliographical references and index.
ISBN 0-295-97759-0 (pbk. : alk. paper)
1. Love Stories, Chinese—Illustrations. 2. Art,
Chinese. 3. Love stories. Japanese—Illustrations.
4. Art, Japanese. 5. Rajasthani poetry—Illustrations.
6. Rajput painting.
I. Arthur M. Sackler Gallery (Smithsonian
Institution) II. Series: Asian art & culture
(Unnumbered)
N8220.L62 1998
700'.4543'095—dc21 98-29249
 CIP

The paper used in the publication meets the mini-
mum requirements for the American National
Standard for Permanence of paper for Printed
Library Materials, z39.48–1984.

Credits
"Revealing the Romance in Chinese Art": figs. 1, 4
Palace Museum, Beijing; figs. 2, 3, 8, 10, 11, 12, 14
Freer Gallery of Art, Smithsonian Institution; figs. 5,
6 National Palace Museum, Taipei, Taiwan; fig. 7
courtesy Museum of Fine Arts, Boston; fig. 9 UTC
and Jiangsu Fine Arts Press, photo by Mr. Li
Yuxiang; fig. 13 courtesy Christie's Images;
"Picturing Love Among the *One Hundred Poets*":
figs. 1, 4, 7, 8, 12 reproduced by permission of the
Tokyo National Museum; figs. 2, 3, 5, 6, 9 courtesy
Heibonsha, Japan; figs. 10, 11, 13, 14 reproduced by
permission of Atomi Gakuen Tanki Daigaku
Toshokan; "Japanese Love Poems": p. 51 photo by
Rudolph Nagel; p. 54 courtesy Ema Sumiko; p. 58
photo by Takamura Hōshū; p. 64 courtesy of
Takamura Tadashi; "*Sakhis,* Love, Devotion, and
Poetry in Rajput Paintings": figs. 1–9; 11 © Arthur M.
Sackler Gallery, Smithsonian Institution, photos by
John Tsantes; fig. 10 photo by Richard Goodbody;
"Reading Love Imagery on the Indian Temple": figs.
1–3, 5–12 Arthur M. Sackler Gallery and Freer
Gallery of Art, Smithsonian Institution, photos by
Neil Greentree; fig. 4 ACSAA, courtesy University of
Michigan

The ecstasy, confusion, and grief of love — love in all its consummate power — have been extolled in art over the millennia. Societies change, audiences evolve, and accordingly, artists and writers have rendered their couples in joyful, intimate embrace or in splendid robes, formally distanced, peering at one another from behind bamboo screens; as auspicious emblems of fertility or as shy, secretive, frustrated. We see the humor and complication of love: desire is generous, stingy, expansive, possessive; passion is thwarted or realized; romance is threatened by parents or rivals even as some lovers are assisted by best friends toward ultimate union. These are universal themes that demand expression, and artistic and literary imagery is rich and wildly varied across cultures. In China, mandarin ducks, said to mate for life, symbolize wedded bliss, and tiny red shoes have sometimes been viewed as sexually arousing. In Japan, black hair once alluded covertly to passion, but in the twentieth century black hair is explicitly erotic; in India, love is divine, enduring in temple sculpture in the form of rapturous nude couples, the territory of gods as well as mortals. To generalize about portrayals of love in Asian art and culture is certainly impossible and not particularly desirable. The authors in this book seek merely to introduce notions of love as manifested in selected painting, poetry, and sculpture of China, Japan, and India.

ATTITUDES ABOUT LOVE in China have cycled between approval and suppression over the centuries, and painting and poetry reflect those shifts. Romantic couples appear in the Chinese canon, but touching is strictly regulated by Confucian custom, so artists often used indirect means to suggest desire. The idea of beautiful nudity — associated with love in many cultures — is absent. Nude or partially clad figures are rare; the human form represents an ethereal inner quality, and the flow of the "life force" is instead suggested by folds of drapery and scarves, created with cadent brush strokes. Although passionate and

erotic encounters do appear, they are veiled and require a knowledge of Chinese literature and Confucian decorum to decode. In her essay, Jan Stuart begins to plumb that history and representation.

Stuart focuses particularly on the panoply of images associated with *The Story of the Western Wing*, alleged to be the most widely read and frequently performed love story in China. She cites a clever, adventurous telling by Wang Shifu (ca. 1250–1300) of this tale of Student Zhang, a poor young scholar who successfully woos Oriole, a beautiful innocent maiden, against her mother's wishes. Stuart begins her discussion of the interplay of story and imagery by remarking that in a 1498 edition woodblock print, the protagonists are in a bedroom, fully clothed, with the man caressing the woman's breast. In a modern reissue (1955) this act of love is concealed by a streaked band—the cycle of suppression and approval continuing well into the twentieth century.

Near the end of his life, the renowned Japanese poet and scholar Fujiwara no Teika (1162–1241) assembled the *Hyakunin isshu* (One hundred poets, one poem each), more than forty of which were originally written as love verse. Over the centuries many artists interpreted and pictured the love and lovers in these poems. But those who did so for festivities such as weddings faced a peculiar problem: how to turn something unfortunate into something auspicious. For as author Joshua Mostow explains, classical love poetry in Japan tells of love denied, not love fulfilled. Rarely do these poems confirm the happiness of love; rather, these are poems of longing.

In the seventeenth century, the artist Kano Tan'yū (1602–1674) and his workshop produced a deluxe album with illustrations of all one hundred poems painted in rich mineral pigments on silk, each poem inscribed on the facing page. The visualizations of these poems in subsequent versions reveal attitudes toward love that vary among men and women of different classes. One album now in the Tokyo National Museum, created for a male audience of the warrior class, stresses the political status of the poets depicted, the disappointments of love, and familiarity with Chinese letters. Those aspects are deemphasized or eliminated in the Date album, which was made for a female audience of the aristocratic class and served as an educational text for dutiful daughters and wives. Another version by woodblock print artist Hishikawa Moronobu (died 1694) includes some parodies, and his illustrations present a range of romantic situations, including homosexual love.

While Mostow considers illustrations associated with classical courtly love poetry, translator Hiroaki Sato provides a more personal tour of Japanese love poetry, focusing on nineteenth- and twentieth-century works. Sato briefly reviews indigenous pre-twentieth-century forms, such as *chōka*, tanka, *renga*, haiku, *kanshi* (poems written in classical Chinese), and longer, flexible styles pursued under Western influence. As in other parts of the world, poets in Japan became bolder and more direct, and in 1914, Takamura Kōtarō (1883–1956) wrote:

> We are full of more lust.
> Like ground heat,
> fierce, fierce —

In his look at literary history, Sato notes there was a certain physicality and energy in Japanese verse prior to the appearance in the early tenth century of the first imperial

anthologies (court poetry) in which the joy of sex simply does not exist. As in China, a stern poetic etiquette evolved, so that the uninitiated would not recognize some of the poems as love songs. Parts of the body were not mentioned, except for black hair, a court lady's prized possession, which accordingly assumed sexual, if veiled, meaning. In a twelfth-century poem, black hair is contained in a memory: "How I lifted her black hair strand by strand as I lie alone rises in my mind's eye," whereas in Yosano Akiko's *Midare-gami* (Hair in disorder), published in 1901, the image is forceful, explicit, even dangerous: "Black hair, a thousand strands of hair, tangled hair, thoughts so tangled, thoughts tangled!" Sato offers a taste of modern poetry, in which forms are fluid and expression more straightforward than in earlier times, demonstrating evolution from an earlier era's subtle, delicate imagery to the audacious, off-center picture presented in "Fish" (1992):

> In a dream
> I was put on his supper table,
> a broiled fish.

In seemingly utter contrast to restrained early poetry and painting in China and Japan, Indian devotional art exuberantly encompasses "love sport"—sexual passion and unruly emotion. Separation from the beloved causes not merely an ache or longing but agony; jealousy is not mastered and contained but rousing and fierce; illicit love is not portrayed as immoral but celebrated for its erotic power.

In Indian love poetry, a *sakhi* is a female friend and messenger who seeks to unite the heroine with her beloved. Through illustrated manuscripts of love poetry, painted in the Rajput (a warrior and ruling caste in western India) courts of northern and western India between the seventeenth and nineteenth centuries, Annapurna Garimella explores the figure of the *sakhi,* a stock figure in romance literature who facilitates the progress of love.

In his devotional lyric *Gita Govinda* (Love song of the dark lord), the twelfth-century poet Jayadeva tells the tumultuous story of the cowherd god Krishna and his lover Radha, a mortal whom later theologians elevated to divine status. In the verse inscribed on the back of one painting, the *sakhi* urges Radha to enter Krishna's bower and

> Revel in the wild luxury on the sweet thicket floor!
> Your laughing face begs ardently for his love.

—lines of untrammeled emotion. Garimella's essay is illustrated with painted leaves from a *Gita Govinda* manuscript, and inscriptions on the paintings are translated. Garimella discusses the effect of the paintings and poetry on the audience, the ambiguous status of Krishna as an object of both religious and erotic reverence, the play between power and eroticism, and gender issues that permeate art.

Thus couples are linked with the divine. Characteristic of India is graphic three-dimensional imagery that honors love itself, carved in stone on the walls of Hindu temples. Portrayals of love were created throughout India from the first century to the nineteenth, but the eleventh-century temples at Khajuraho are particularly renowned for dynamic erotic sculpture. Vidya Dehejia's essay delves into the artistic achievement and iconographic programs evident in the sculpture.

The culture of medieval India (ca. 600–1300) exhibited attitudes toward sexuality

very different from those now current, and these erotic sculptures were displayed on the outer walls of temples in a public arena. A large, diverse audience would have seen these vividly sensual intertwined couples. Sexual energy was highly valued, and a ruler would strive for a balance between "sexual vitality, which implied regal power, and control of the senses, which spoke of yogic power." The three temples Dehejia discusses were all royal commissions of the Chandella monarchs (ruled tenth century). In contrast to many societies, a couple was an auspicious emblem, representing fertility and abundance, appropriate for adorning the walls of palace, temple, or Buddhist chapel.

A UNIVERSALLY IRRESISTIBLE theme, love of course propels artists and audiences to create and enjoy poetry and art. In Asian cultures, whether depicted as erotic embrace or polite gesture, the subject of love has occupied both divine and human realms, offering us continuing avenues of study, sustenance, inspiration, and delight. ☙

— Karen Sagstetter

ACKNOWLEDGMENTS

Love in Asian Art and Culture developed because of the commitment and energy of a number of creative professionals. Milo Cleveland Beach, director, and Thomas W. Lentz, deputy director, of the Arthur M. Sackler Gallery and Freer Gallery of Art, have continually provided insightful critical comments as well as support. Vidya Dehejia, associate director and chief curator, suggested that the theme of love offered intriguing and fulfilling pathways into Asian art. The gallery wishes to thank Ann Yonemura, associate curator of Japanese art, for invaluable consultations and reviews; editor Ann Hofstra Grogg for vigorous, thorough editing that greatly enhanced the development of the book; and Carol Beehler, art director for publications, who brought harmony and balance to this fascinating material. Loi Thai, publications assistant, provided consistent care in handling administrative matters and manuscripts. The gallery is grateful to colleagues at the University of Washington Press, especially Pat Soden, director; Veronica Seyd, assistant director and production manager; and Don Ellegood, director emeritus, whose good work and enthusiasm propel the Asian Art & Culture series to the shelves of bookstores. ☙

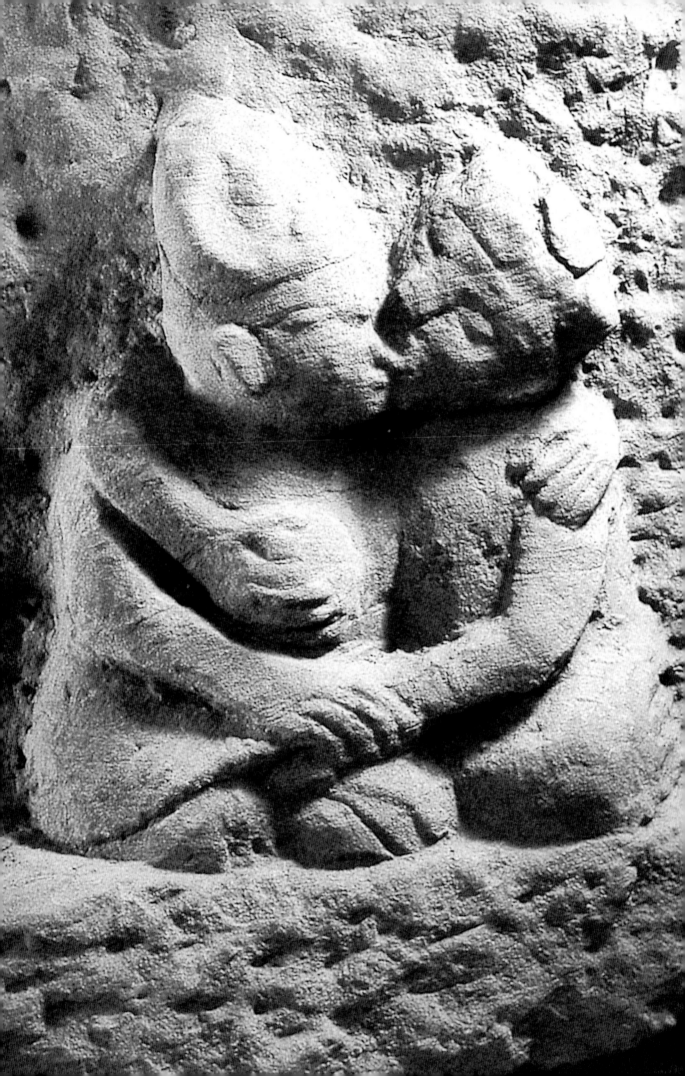

Two birds with the wings of one

REVEALING THE ROMANCE IN CHINESE ART

Jan Stuart

A modern reissue of China's most famous tale of love reveals much about attitudes toward romance in China, which over many centuries have cycled between approbation and censorship. *The Story of the Western Wing* (Xixiang ji; also translated as *The Romance of the Western Chamber*) by Wang Shifu (ca. 1250–1300) celebrates the love between a talented young scholar and a beautiful maiden. A deluxe, illustrated book edition produced in 1498 includes a woodblock print of the protagonists in a bedroom, both fully clothed, with the man caressing the woman's breast. In the modern reissue (1955), however, this act of love is concealed by a streaked band superimposed at chest level.[1]

The romantic and specifically erotic content of Chinese art has so long been suppressed or disguised that modern viewers often presume love is simply unimportant as a theme. Compared to other cultures, its treatment in China, except for brief interludes, may seem indirect, suggested only through images of flowers or birds and allusions to traditional Chinese literature that modern Chinese or Western audiences may not always recognize. Perhaps the fact that in ancient China there were no corollaries to the Greek and Roman gods, such as Eros, who pursued passionate love, or myths paralleling the stories of India's cosmic creator Shiva, with his voluptuous consorts, explains the common impression that in China love is not a subject for art. Moreover, scholarly preoccupation with literati art that favors landscape has marginalized studies of art devoted to romance.[2] Finally, a prudishness especially strong in China from about the middle of the Qing dynasty (1644–1911) has only recently begun to recede, as the band across the fifteenth-century woodblock print in *The Story of the Western Wing* suggests.

Romantic couples do, however, appear in the Chinese repertoire, but because touching is strictly regulated in Confucian etiquette, artists generally employed more indirect

Figure 1. *Kissing Couple,* China, Pengshan Xian, Sichuan Province, Eastern Han dynasty, A.D. 25–220. Stone sculptural relief, 49 cm high. Palace Museum, Beijing

means to suggest the emotion of love. Physical gestures and nude or partially disrobed figures are extremely rare in Chinese art. In presenting the human form, Chinese artists have been less concerned with representing its corporeal nature than with capturing the ineffable inner quality, or life force *(qi)*, of a person. *Qi* is analogous to pulsating energy fields coursing through a person's body, and its flow is suggested by drapery and rippling scarves created with rhythmic brushstrokes. In China, the notion of sublime nudity that is associated with expressions of love in many cultures is absent.

Chinese artists could anticipate that a viewer would have a deep familiarity with literature, and they felt free to use literary allusions to assign meaning to art. There was much from which to choose. Love was already a topic in China's earliest anthology of verse, the *Book of Songs,* compiled between the eleventh and seventh centuries B.C. A corpus of more openly erotic and elegiacal rhapsodies called the *Songs of Chu* appeared in the fourth century B.C. And in the Southern Dynasties (420–589), a brilliant anthology of 656 love poems called *New Songs from a Jade Terrace* brought romantic verse to a new height. As the scholar Ellen Laing has demonstrated, many of these poems were a source through the ages for painters.[3] The poems, summarizes Anne Birrell, address "wooing, marriage, divorce, celebrations, obsessions, laments, new love, old love, dead love." But as early as the Han dynasty (206 B.C.– A.D. 220), some Confucian scholars who became uneasy with references to love and eroticism in the *Book of Songs* and literature developed, as Birrell explains,

> elaborate explanations and interpretations of quite innocent songs [poems], giving them a didactic tone. Thus a marriage song becomes an allegory for the exemplary marital relationship between a ruler and his consort. Or a lovers' elopement becomes an allegory for dissident peasants fleeing to another country. *The Songs of Ch'u* [Chu] suffered a similar fate . . . [its] highly complex symbolic language . . . reduced to mere prosaic allegory of a political, moralising nature.[4]

Romantic relationships came to be construed as modeling the correct political order and the proper relationship between a ruler and subject. The same transformation of romantic passion into allegory occurred in art. But since the visual arts are inherently more explicit and public than writing, it was difficult to select themes for depiction. Words exist within a shadowy realm between liminal and subliminal experience, and their meaning can be more easily veiled than pictorial images. Differences in media may thus account for the greater emphasis on love in Chinese literature than in paintings.

Allegory and Allusion

While most lovers pictured in Chinese art can be associated with a literary source, the context for some of the earliest images of a man and woman embracing is hard to reconstruct. A few early images of intimate couples have been discovered in tombs dating to the Eastern Han dynasty (A.D. 25–220) in Sichuan Province, but their significance is imperfectly understood. Two decorated hollow bricks show scenes of copulation between a man and woman, with a third man watching, and a stone monument depicts a naked couple

kissing, with the man gently fondling the woman's breast (fig. 1). The images may have fulfilled different purposes; some scholars speculate that the hollow bricks buried within the tomb illustrate a conventional (and as yet unidentified) story.[5] The stone monument, which was

Figure 2. Detail, copy of painting attributed to Gu Kaizhi, *The Nymph of the Luo River*, China, Southern Song dynasty, 1127–1279. Handscroll, ink and color on paper, 24 x 310 cm. Freer Gallery of Art, F14.53, Gift of Charles Lang Freer

originally located over the lintel of a stone tomb in a tableau of auspicious images, may have had religious import. Its prominent display in an age dominated by strict Confucian sexual taboos suggests it embodied some symbolic meaning beyond a glorification of the joy of human intimacy. The scholar Song Baiyin speculates that the sculpture referred to beliefs about the afterlife.[6] The woman likely represents a Jade Maiden, who appears in Daoist literature as one possessing the secret to eternal life. If a mortal man is a sincere adept, a Jade Maiden will bind to him as a bride to her groom and impart her esoteric knowledge. Some texts describe a Jade Maiden who exhales red breath in a kind of cosmic kiss, which may be the subject of this sculpture.

More typically lovers in Chinese art are based on literary sources and presented in modest poses, as exemplified by *The Nymph of the Luo River*, associated with the artist Gu Kaizhi (ca. 344–ca. 406) (fig. 2) and based on a famous romantic poem by Cao Zhi (129–232). The story depicts love at first sight between a prince and an ethereal nymph or goddess who "glimmers like sunshine." Cao's rhapsody begins when the prince spies the splendiferous nymph at the river's edge and offers her a jade pendant to pledge his love. The goddess accepts it and points to the river's depths, where their assignation will take place. Momentarily fearing the supernatural union, the prince hesitates, and the goddess reacts swiftly to his lack of trust. As she departs, she vows to love the prince eternally but insists that they remain forever in separate realms. Repentant, the prince discovers it is now too late to call the goddess back. Both suffer inconsolably from their unconsummated love.

Poem and painting express a couple's desire for perfect union while also warning of the dangers of love gone awry. Whether Cao intended his verse as political allegory, it has been interpreted as such. The goddess's devotion in the face of the prince's rejection has

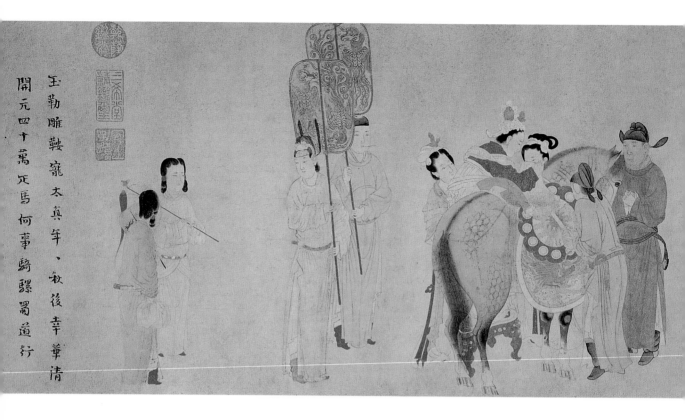

開元四十萬疋馬何事騎騾署道行

玉勒雕鞍寵太真年，秋後幸華清

Figure 3. Attributed to Qian Xuan, *Yang Guifei Mounting a Horse*, China, probably Ming dynasty, 1368–1644. Handscroll, ink and color on paper, 29.5 x 117.0 cm. Purchase—Freer Gallery of Art, 57.14

been construed as alluding to Cao Zhi's undying loyalty to his brother, Emperor Wen (183–236), despite the latter's ill treatment of him. Unquestioning loyalty to the ruler was an important Confucian precept. The tragedy that befell the prince after his momentary hesitation has also been endowed with political meaning, warning that disaster will follow if a ruler wavers in his actions. Romantic encounters between mortals were just as susceptible to political interpretation. *Yang Guifei Mounting a Horse*, traditionally attributed to Qian Xuan (ca. 1235–after 1300) but probably later, illustrates the Tang Emperor Xuanzhong, better known as Ming Huang (reigned 712–56), watching his fashionably corpulent concubine Yang Guifei (ca. 720–756) mount a horse (fig. 3). The couple is renowned for their passion, and the painter no doubt counted on viewers' reading the subject as a double entendre, since "mounting a horse" is a colloquial expression for making love. Viewers also brought historical and literary knowledge that colored interpretation of the painting, making it a cautionary tale against obsessive love.

Yang, the daughter of a petty functionary, was inducted into the imperial harem because of her exceptional beauty. Ming Huang became fixated on her and, against standard practice, granted her an exceptionally high title, second only to that of the empress. The emperor also ignored Yang's subsequent political machinations and promotion of her clan members to court, which ultimately triggered a rebellion that forced the fall of the capital. The emperor, Yang, and his loyal soldiers fled for their lives, but en route the soldiers mutinied and demanded Yang's death. The emperor never recovered from his grief.

The heartrending destruction (personal and political) that resulted from unbridled passion was immortalized in a poem by Bai Juyi (772–846), the "Song of Unending Sorrow."

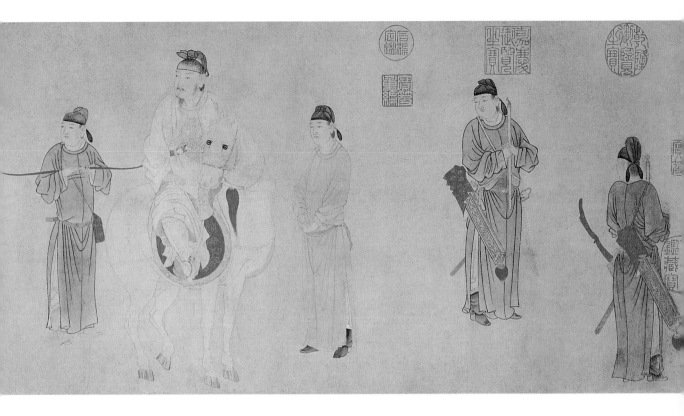

Describing the depth of their romantic attachment, the poet imagined that the lovers

> told each other secretly in the quiet midnight world
> That we wished to fly to heaven, two birds with the wings of one,
> And to grow together on earth, two branches on one tree.[7]

Any evocation of Ming Huang and Yang Guifei in art was bound to be bittersweet, calling forth the inextricably interwoven pleasures and dangers of love.

A famous departure from the indirect approach to romance is *The Night Entertainment of Han Xizai,* a handscroll attributed to the tenth-century painter Gu Hongzhong and preserved in a twelfth-century copy (fig. 4). Gu allegedly painted the scroll for his imperial patron, Li Yu (reigned 961–75), who wished to spy on the reputedly licentious court minister Han Xizai (active ca. 960–75). In the painting, Han Xizai and a group of male guests enjoy the company of seductive sing-song girls who play music and hint at promises of physical love. In a discreet corner of the room a couple sport completely hidden under a pile of bedcovers.

The exquisitely painted *Night Entertainment* entered the collection of Emperor Song Huizong (reigned 1101–26), a great collector and patron of the arts. He apparently found it prudent not to comment on the erotic content of the scroll other than to suggest that perhaps it should not have been painted, recording as it does things better left private.[8] Other commentaries imbued the image with hidden political meaning. Some suggested that it depicted Han Xizai's strategy for absenting himself from the unstable court by feigning an inappropriate fondness for women.

The perspective used to present the unfolding sexual drama in *The Night Entertainment* distances the viewer into the role of a voyeur. While the figures in the scroll

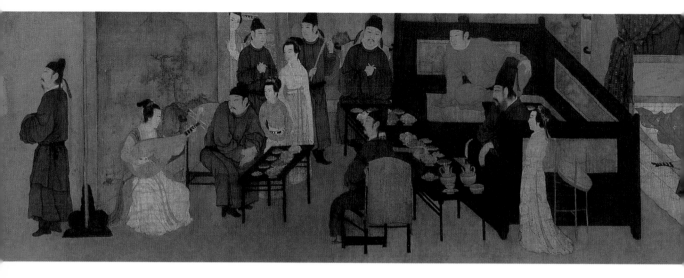

Figure 4. Detail, *The Night Entertainment of Han Xizai*, attributed to Gu Hongzhong, China, Southern Song dynasty, 12th-century copy. Handscroll, ink and color on silk, 28.7 x 335.5 cm. Palace Museum, Beijing

Figure 5. Right: Tang Yin, *Tao Gu Presenting a Poem*, China, Ming dynasty, ca. 1515. Hanging scroll, ink and color on paper, 168.8 x 102.1 cm. National Palace Museum, Taipei, Taiwan

communicate with each other, they make no direct eye contact with the viewer. During the more tolerant Ming dynasty (1368–1644), when the painting was copied again, the anonymous artist showed Han Xizai glancing outward, as if to invite the viewer to join the party.

New trends in romantic art in the late Ming dynasty are exemplified in Tang Yin's (1470–1524) alluring work, *Tao Gu Presenting a Poem* (fig. 5). It was painted during a period when new ideas about the importance of personal action (as opposed to social consciousness) helped to legitimize a man's desire to choose his own lover instead of accepting the wife selected for him by his parents in a contract of arranged marriage designed to benefit the extended family unit. Sometimes a man who chose his own lover made her a primary wife, but she might be brought into a family as a concubine. Romantic love took on new respectability in the Ming dynasty, and authors tried to promote its social value by writing that love encouraged moral and spiritual self-cultivation.[9]

In this climate, Tang Yin depicted in an unabashedly erotic tone the encounter between the scholar Tao Gu (903–970) and a courtesan named Qin, a story loosely based on a real incident. By today's standards the painting may look tame, but in comparison to earlier works, it is considerably more direct. In an unusual gesture, Tang alludes to his own romantic pleasures by using the word "I" *(wo)* in his inscription on the painting, and he appropriated Tao's story to reflect his own feelings, identifying with him as an alter-ego.

According to the popular story, Tao Gu was traveling as an official envoy to the Southern Tang court (923–937) when he decided to spend a night at a lodge. There he mistook the courtesan Qin for the tavern keeper's daughter and wrote her a poem with a seductive proposition that she gladly accepted. The next day, at an official banquet hosted by the emperor, Tao had his wine cup filled by the same woman, whom he then recognized as the ruler's favorite consort. He had been set up by Qin to be tempted into transgressing the taboo against sleeping with a member of the imperial household, thus weakening his political effectiveness.

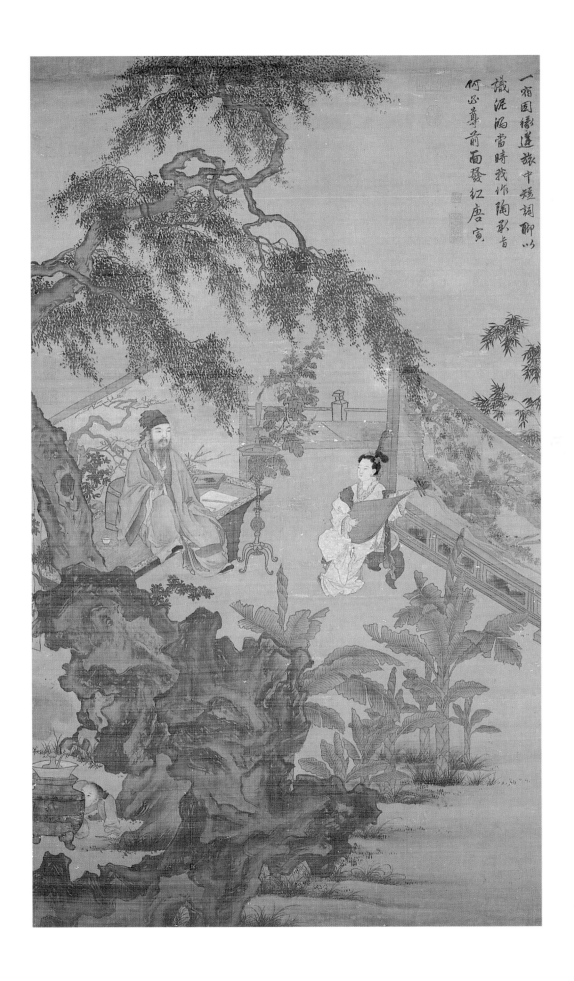

一宿因緣逐逝旅中短詞聊以
識泥鴻當時我作陶歌者
何必章前面髮紅唐寅

Tang Yin painted the couple's nocturnal assignation in a garden — a favorite meeting place for lovers in Chinese literature — using the setting to stir amorous longings. The flaming red candle, symbol of the wedding bed and passionate encounters, and the courtesan's tiny red shoes — considered to be sexually arousing in Chinese culture — both suggest physical intimacy. At first glance, Tao Gu appears to be sitting demurely. But, in fact, in an unusually physically demonstrative gesture, he is slapping his knee in time with a song strummed by Qin, who is the object of his desire. His gesture reverberates with sexual anticipation. Tang Yin further intensifies their passion by placing them together in a tightly framed enclosure bounded by two large screens, which echo the clapping and music, heightening the erotic excitement so that it seems almost palpable.

Tang Yin, who was famous for his romantic liaisons with courtesans, took advantage of his daringly direct painting to refer to his own view that sexual indulgences should entail no shame. He inscribed this poem on the painting:

> A one night love affair in the traveler's lodge,
> A short verse makes the acquaintance.
> If I were Tao Gu at that time,
> Why should I blush before the honorable [ruler]!

To emphasize this point, Tao Gu seems to simultaneously glance at the sumptuously dressed courtesan while also coyly arching his brow toward the viewer, issuing an invitation to partake in vicarious pleasure.

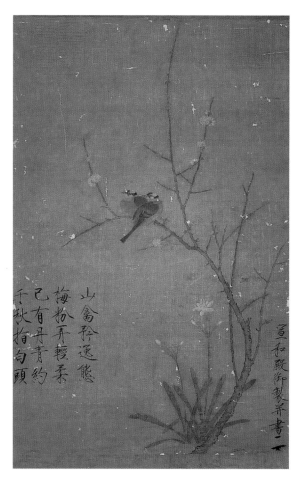

Not all references to love are as direct as figure paintings. In Chinese literature and art, birds, flowers, and butterflies are frequently encoded with references to spiritual and physical love. Flowers and birds can appear in a painting to suggest romantic and erotic allusions, or often they are combined with a solitary woman to tease out a reading of lovelornness. One of the best-known symbols for a happily married couple is a pair of mandarin ducks, who are said to mate for life. In *Wild Birds and Winter Sweet,* attributed to Emperor Song Huizong, we see another choice of metaphor for love (fig. 6). Here, as the inscription makes clear, the two white-headed songbirds on a branch are symbols of a pledge for long-lasting love, a promise to grow old and white-haired together. The overlapping birds allude to the couple's physical intimacy.

Several types of flowering trees have richly nuanced imagery. The plum tree first appears in the *Book of Songs* as a metaphor for a girl's coming of age, which is likened to the

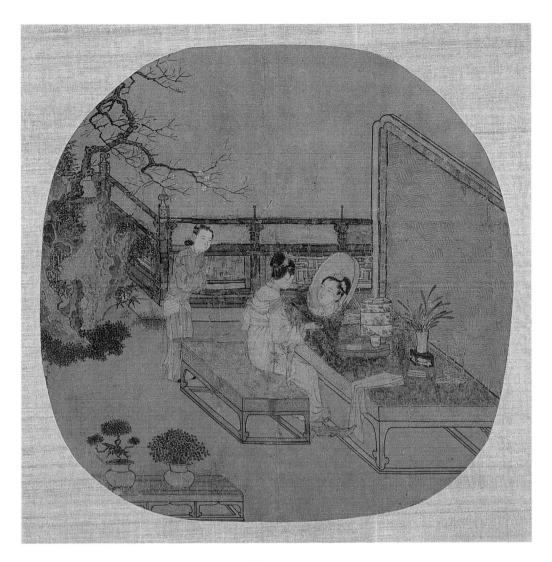

ripening fruit. Gradually the delicate blossoms of the tree replaced the fruit as a key image. Poets assigned the flowering plum tree a female persona, and they often used the pale pink blossoms that open so fleetingly as a symbol for a woman's transient beauty.[10] Many Song dynasty (960–1279) paintings of a solitary woman include a blossoming plum tree to allude to the impermanence of her beauty and, by extension, to her longing for love once she has passed her prime.

The floral imagery in the refined album leaf *Lady at Her Dressing Table in a Garden,* by Su Hanchen (active 1120s–60s), stands as a metaphor for a woman's desire to attract a man's affection (fig. 7). The woman scrutinizes her face in an oversized mirror, forlornly preparing herself in the hopes of attracting her lover's return. The theme of this painting, also common in *New Songs from a Jade Terrace,* was probably inspired by poetry.

The flowering plum tree in the upper left symbolizes feminine elegance and at the same time warns of its ephemeral nature. The narcissi in a vase on the table are a conven-

Figure 6. Left: Attributed to Emperor Song Huizong, *Wild Birds and Winter Sweet,* China, Northern Song dynasty, 12th century. Hanging scroll, ink and color on silk, 83.3 x 53.3 cm. National Palace Museum, Taipei, Taiwan

Figure 7. Above: Su Hanchen, *Lady at Her Dressing Table in a Garden,* China, Southern Song dynasty, mid-12th century. Fan mounted as an album leaf, ink and color on silk, 25.2 x 26.7 cm. Museum of Fine Arts, Boston, Denman Waldo Ross Collection

tional metaphor both for a woman with a noble nature and for a happily married couple. Their name in Chinese, *shuixian hua,* literally means "immortal in the water flower," and the vase is displayed before a screen decorated with undulating waves that stands in front of the dressing table. The lady's glance encompasses both the narcissi and the image of water, suggesting self-identification and her hope to have her beauty and marriage become immortal like the name of the flower. But the plum tree cruelly reminds that a woman's beauty is short-lived.

The romantic longings in *Lady at Her Dressing Table* are heightened by an undercurrent of eroticism suggested by the woman's tiny red slipper resting on the bottom rung of the table. Bound feet were considered sexually alluring, and therefore a woman properly kept her shoes hidden under a long hem, revealing them only to a lover. Exposure of the shoe — especially a red one, the color worn on a wedding night — underscores the painting's evocation of romantic longing and melancholy.

After several centuries during which the plum's principal meaning in art changed from representing female beauty to symbolizing a scholar's moral purity, Jin Nong (1687–1764) revived its original meaning in *Blossoming Plum,* dated 1759 (fig. 8). He painted this scroll when his patron, Jiang Chun (1721–89), brought a new concubine into the household.[11] The intertwining tree branches dotted with dark ink or bright pink blossoms suggest a man and woman in close embrace. The inscribed poem also personifies the delicate plum flowers as a beauty who is the object of a man's love. Painted in Yangzhou, a flourishing commercial city known as the center of courtesan culture during Jin's lifetime, the scroll indirectly evokes issues of the day such as the commoditization of women and commercialization of love. *Blossoming Plum* is a magnificent example of a seemingly innocent flower painting that is charged with erotic implications in the culture of late Ming–Qing China.

The Story of the Western Wing

More than any other romantic image, *The Story of the Western Wing* came to symbolize love in late Ming and Qing art — in paintings, book illustrations, porcelain decorations, textiles, and carvings. Between 1600 and 1900, Wang Shifu's play went through more than a hundred editions, and in the Ming dynasty alone, when deluxe illustrated books were fashionable, at least thirty were illustrated.[12] It is alleged to be the most widely read and frequently performed love story in China.

The Story of the Western Wing is the tale of an impoverished young scholar who falls in love with and successfully woos a beautiful, chaste maiden against her mother's wishes. The plot is conventional, but in Wang Shifu's witty and often sexually bold telling of the story, the Ming and Qing dynasty readers could recognize their own dreams and hopes to choose a partner based on love instead of relying solely on their parents' arrangements. The story opens with the talented Student Zhang (also known as Zhang Gong and Zhang Junrui) en route to the capital to take the civil service

Figure 8. Jin Nong, *Blossoming Plum,* China, Qing dynasty, dated 1759. Hanging scroll, ink and color on paper, 130.2 x 28.2 cm. Purchase — Freer Gallery of Art, 65.10

examinations. He stops to rest at a monastery, where by chance he encounters the beautiful maiden, Oriole (Cui Yingying), accompanied by her cheeky maid and confidant Crimson (Hongniang). Oriole temporarily resides at the temple with her stern, widowed mother, Madam Cui, who is preparing funeral services for her late husband, the prime minister.

Overcome by infatuation for Oriole, Zhang rents rooms in the temple. But Madam Cui strictly cloisters her daughter, whom she has promised in marriage to her cousin Zheng Heng. Student Zhang connives with Crimson to communicate with Oriole, who is herself secretly attracted to him. When the evil Flying Tiger, General Sun, lays siege to the temple and demands Oriole as his wife, Madam Cui promises her daughter to whomever can save them from attack. Student Zhang sends word to a powerful military friend who vanquishes Sun. Instead of keeping her promise about marriage, however, Madam Cui proclaims that Student Zhang and Oriole should honor each other as "brother and sister."

Devastated, Zhang appeals to Crimson for help, who suggests that he seduce her mistress by playing his zither outside the courtyard wall. (In the double entendre common in Wang Shifu's text, the zither is both a symbol of a cultivated scholar and a pun for the sexual act.) Zhang also sends Oriole a love poem, which she answers with a riddle that he interprets as an invitation to jump over the wall for a moonlit tryst. As soon as he enters the garden, however, Oriole sends Crimson to turn him away. Zhang then falls victim to a debilitating lovesickness, which serves to establish his worth and sincerity in Oriole's mind. Encouraged by Crimson, she finally agrees to pay a secret visit to Zhang's bed to cure him.

After discovering their liaison, Madam Cui reluctantly agrees to their marriage, if Zhang first passes the examinations at the highest level. During Student Zhang's absence to win honors, Zheng Heng, a caricature of vulgarity, arrives and deceitfully convinces Madam Cui that Student Zhang is already married. Just as Zheng Heng is about to marry Oriole himself, Zhang returns to claim his rightful bride and they are united in a splendid marriage ceremony.

Wang Shifu's play is brilliantly original, although loosely based on a semibiographical story, "The Tale of Oriole," written by Yuan Zhen (779–831) in the Tang dynasty (618–907) and on a second generation reworking of that tale by the poet Dong Jieyuan (ca. 1190–1280). Freely inventing dialogue and situations, including a new ending, Wang modernized the story and

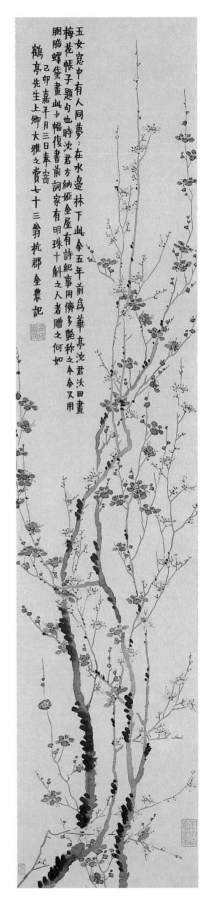

set new standards for romantic fiction that would influence later authors.

Despite Wang's sometimes erotic language, his lively and entertaining writing ultimately won a place for the play as an exemplary expression of tender sentiment between young lovers. But the story was not without controversy: Was it morally uplifting, or just plain lustful? A preface to a 1498 edition starts with praise for the author but also states that Wang Shifu "was punished for writing the play by having his tongue pulled out in hell."[13]

A scene in the famous eighteenth-century novel, *The Dream of the Red Chamber* (Honglou meng), reveals continued ambivalence about the story. The male protagonist, Jia Baoyu, eagerly devours *The Story of the Western Wing*, but hides it from his female cousin Lin Daiyu on account of its ribald nature. She finds the book anyway and savors it, only to later dismiss it in public as crude and disgusting. Nonetheless, *The Story of the Western Wing* was so popular that it was revised several times in the Ming and Qing dynasties, and paintings, books, and art objects decorated with scenes of the drama were widely sought after by all classes. Some

Figure 9. Lattice window decoration, China, Hongcun Village, Anhui Province, Qing dynasty, 19th century. Wood carving

of the latter versions of Wang's play, notably Jin Shengtan's (1610–61), refined the sexual language to avoid readers' condemnation, subsequently encouraging an even wider circulation of illustrated editions of the play. Jin went so far as to write a preface defending the behavior of the young lovers, including their choosing of one another in the face of parental disapproval.

Gradually the debate about *The Story of the Western Wing* was settled in favor of accepting it as a wholesome love story. A lattice window decoration from a nineteenth-century home in Anhui Province represents this final, wholehearted approval (fig. 9). The wood carving illustrates the defining moment in the tale, when Student Zhang climbs over the garden wall to pay an illicit visit to chaste Oriole, shown in the company of her maid. A large character above the scene declares "good fortune" *(fu).* The blessing demonstrates the extent to which Wang's drama had been stripped of eroticism in the popular imagination.

Before the Ming dynasty, the play was seldom illustrated. A few prints and paintings that portray Oriole are recorded, and some scholars have identified two scenes on a blue-and-white porcelain jar made between 1320 and 1350 as early illustrations of *The Story of the Western Wing*. This identification is, however, highly speculative.[14] The first major —

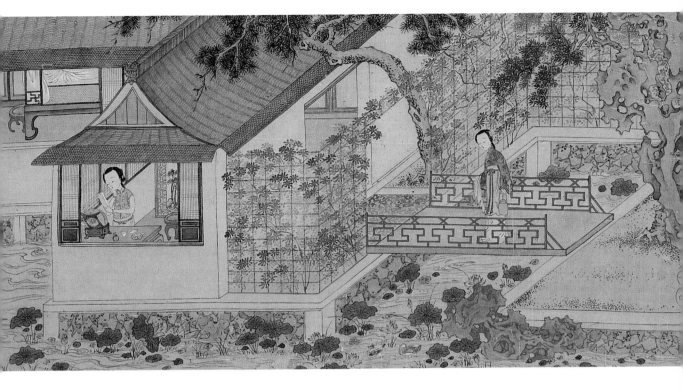

and most fully ever—illustrated edition of the play is the woodblock-printed book produced in 1498, mentioned at the beginning of this essay. By the late sixteenth century, the number of book illustrations was typically reduced to twenty, one for each act of the play. *The Story of the Western Wing* had become so well known that "it would have seemed unnecessary, even prosaic, to illustrate the entire story scene by scene, page by page. . . . The change from continuous narrative to selected

scenes in book illustrations signals the maturity of a tradition."[15] Artists working independently of text, such as painters and porcelain decorators, typically further reduced the number of scenes, often to one. Student Zhang climbing over the garden wall was the favorite.

The protagonists in *The Story of the Western Wing* are often represented as characterizations of their social and theatrical roles without much individual detail or expression in their faces. Illustrators and painters tended to follow standard conventions for the figures, but they sometimes enhanced the story by special details in the pictorial setting. A pair of mandarin ducks, symbols of marital bliss, added to a scene in the 1498 edition of *The Story of the Western Wing* exemplifies this artistic license. Although ducks are not mentioned in the play, their depiction would presage the happy (and respectably married) union between Oriole and Student Zhang. An anonymous eighteenth-century album painter made sophisticated use of the same detail. Portraying Oriole reading her first love letter from Student Zhang (fig. 10), the painter placed mandarin ducks swimming in a lotus pond to anticipate their happy marriage, thus mitigating the impropriety of Zhang's secret contact. But elite viewers who had a thorough background in ancient literary traditions also associated the lotus with female sexuality and love.

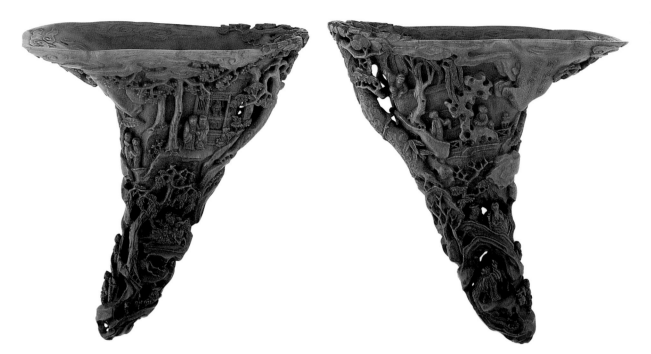

Figures 11, 12. Rhyton carved with scenes from *The Story of the Western Wing*, China, Ming dynasty, 17th century. Rhinoceros horn, 21.0 x 18.8 cm. Purchase — Freer Gallery of Art, 70.1

Not all art objects decorated with scenes from *The Story of the Western Wing* try to deny its fundamental eroticism. An example is a full-tip rhinoceros horn cup, dating to the seventeenth century, carved with scenes from the play (figs. 11, 12). Since the Tang dynasty, rhinoceros horn rhytons were prized in China because the rhinoceros was believed to be divine and its horn an aphrodisiac. Rhytons were never common drinking vessels in China, but they enjoyed a special vogue in the seventeenth century, when they might be used at amorous drinking parties, as seen in figure 13. The rhino horn's erotic associations were well known in the Ming dynasty, having been immortalized by a line of verse by the Tang poet Li Shangyin (812–58), who described the white groove from the horn's tip to its bottom as a symbol of sexual love. In *The Story of the Western Wing*, this erotic allusion is invoked to describe Oriole's pining for Student Zhang. Crimson informs her mistress that she is going to tell Zhang:

> Spring grief weighs down the tips of [my mistress's] brows.
> Her lingering illness would be cured,
> If only the smallest groove were opened down the divine rhinoceros horn.[16]

The decorator of the seventeenth-century rhyton knew that his audience would be familiar with this line, which would reinforce the symbolism of the rhyton. The scenes illustrate the young lovers' initial meeting in front of the monastery's Buddha Hall; Zhang's scaling of the courtyard wall; the vanquishing of evil General Sun; and Oriole's bidding a temporary farewell to Zhang as he departs for the capital. At the top of the horn is inscribed a line from the play: "Even before the wine of parting is drunk, already my heart is broken." This reference is to Zhang's departure for the capital after the lovers have pledged marriage — a reminder of the respectability of their romance. The line was also appropriate for fantasizing about ribald, romantic encounters like that shown in figure 13.

Eroticism Disguised Again

A large, sumptuously detailed painting on silk has traditionally been identified as a scene from *The Story of the Western Wing,* but no securely identified painting or woodblock print of the tale shares its imagery (fig. 14). The painting's traditional identification is based on a Chinese title slip that reads: "Portrait of Cui Yingying [Oriole] by Zhou Wenju [active tenth century] of the Five Dynasties. A Masterpiece. Remounted in the *bingchen* year [possibly corresponding to 1854 or 1914]." But labels that attribute paintings to remote masters of antiquity were commonly added by dealers to impress foreign, and sometimes Chinese, clients, and they cannot be taken at face value. In addition, the painting lacks a signature or seals (a collector's seal may have been trimmed from the lower left where there is now a patch). The style of the figures and the background — especially the moon window painted with Western perspective — resembles details associated with Yangzhou workshops during the eighteenth century.[17] Although it is impossible to be sure of the painting's provenance, a date of mid-eighteenth-century seems appropriate.

Moreover, only generous imagination could transform the two coquettish women and flirtatious man depicted here into Oriole, Crimson, and Student Zhang, and, even so, there would be no reason to title this "portrait" of Oriole. If the title slip truly applied to this image, it might be expected to read "Oriole and

Figure 13. Detail, artist unknown, *Drinking Party,* China, Ming–Qing dynasties, 17th–18th century. Hanging scroll, ink and color on silk, 54 x 72.5 cm

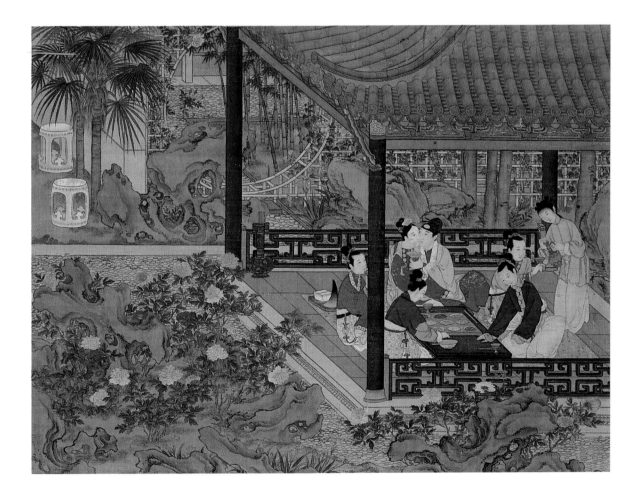

Figure 14. Artist unknown, *Three Figures in a Room* (previously titled *Scene from Romance of the Western Chamber*), China, Qing dynasty, mid-18th century. Ink, color, and gold on silk, mounted on panel, 198.5 x 130.6 cm. Freer Gallery of Art, 16.517, Gift of Charles Lang Freer

Student Zhang in *The Story of the Western Wing.*" The label may have originally belonged to another painting or been fabricated, perhaps a dealer's sleight of hand connecting the painting with China's most famous romance, an association that has remained unquestioned until now. By the early twentieth century, the painting belonged to E. A. Strehlneek, a Shanghai dealer who published it as an ancient portrait of Oriole. Giving the woman seated at the table a respectable identity may have helped sell the painting, and it was purchased by Charles Lang Freer sometime around 1914.[18]

In the center of the picture, a young dandy drapes his leg over the arm of a spotted bamboo chair in an emphatically casual but suggestive pose associated with portraits of female courtesans. He looks to his right at a woman wearing a phoenix hairpin and the sumptuous gold and pearl bracelets that would be expected of a glamorous courtesan. She holds a pale pink rose in her hand that she offers to the man—the key gesture in the painting. Previously this gesture has been the subject of controversy; one author described Oriole turning "to receive the flower offered by Chang Chün-jui [Student Zhang], to whom she is secretly betrothed."[19] Robert Maeda corrected the record, but the erotic implications are even more specific.[20] The man actually extends several fingers toward the rose, sensuously patting its petals and inserting one digit into its heart. The erotic implications of this action resonate in many cultures, but in China the meaning is very specific. The heart of a flower (*huaxin*) is a standard metaphor for a woman's clitoris and vagina. There is no escaping the intention of this choreographed movement of the man's hand; moreover, the figures' hands almost overlap, hinting at the brush of flesh. Quite strikingly, both the man's and woman's sleeves have slipped down, exposing more of their arms than generally seen in a Chinese figure painting.

Beyond the boldness of this action, other details suggest the painting is not based on *The Story of the Western Wing.* In securely identified illustrations of Wang's story, the tryst between Oriole and Student Zhang follows the playwright's convention and is shown occurring in his bedroom, not in a semipublic reception room, as here. The sexual act may be alluded to by Zhang kneeling before Oriole, or by their sitting on the bed preparing to undress; occasionally they are portrayed hidden under bedcovers. Typically Crimson is depicted standing outside of the room peeking in, like a voyeur. Here the sumptuous clothing and tall stature of the second woman in the painting belie her status as a maid. Her posture brushing her sleeve against her chin has been identified as a convention associated with "love-tormented beauties," which is also inappropriate if we are to understand her as Crimson.[21] Finally, the lack of a candle in this painting, which in other illustrations signifies the lovers' secret nocturnal rendezvous, suggests the possibility that the permissive behavior occurs in the daytime, adding more scandal. Other erotic details in the painting do not comfortably fit the identification of *The Story of the Western Wing.* The woman who holds the flower deliberately exposes her bound foot in a most titillating pose that is emphasized by the rectangular frame created by the chair. Showing her trousers and the white bandages that shape a bound foot beneath her pleated skirt, she lifts her foot to reveal the pointed "phoenix toe" of the red shoe and its tiny high heel. All these elements of clothing are considered to be highly sensual. Wang Shifu mentions Oriole's tiny embroi-

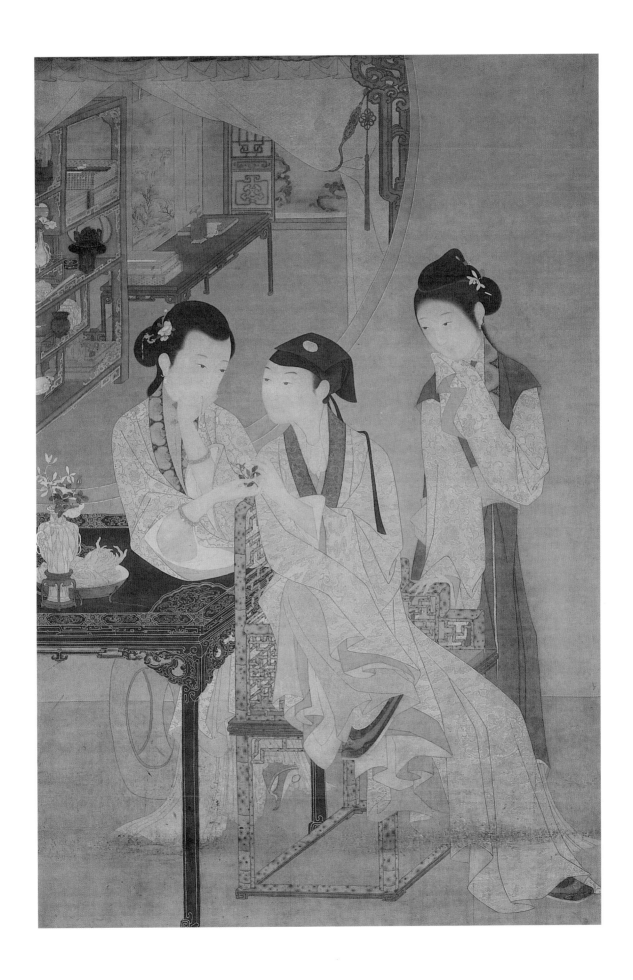

dered shoes in the bedroom scene, so the image of a bound shoe does not preclude the woman's being Oriole. But it is difficult to imagine the chaste Oriole on her first meeting with Student Zhang having the experience or boldness to show off like a courtesan.

The elegantly appointed setting of this painting also contributes to its erotic content. A vase with wild orchid blossoms and a rose suggests female sensuality. The Chinese rose (*yueji hua*), which blooms almost year-round, is often called a flower of eternal spring. Here the reference evokes spring as the season of love. The wild orchid has a richer, more nuanced history of associations with women. This delicate blossom, which grows in untrammeled valleys, symbolizes a lovely girl living in seclusion and, by extension, a woman's bedchamber and even her body. In Ming and Qing literature, a man's union with a courtesan was described as "finding a delicate orchid in a secluded valley."[22] The "Buddha-hand," or fragrant citron, placed in a dish on the table also carries a sexual innuendo. The nonedible fruit is enjoyed for its perfume, but its unusual shape can also suggest female genitalia.

Seldom are nonpornographic images in Chinese art as openly licentious as in this painting, though they may seem tame by modern standards. Hung on the wall or mounted in a freestanding screen in a man's private rooms or a courtesan's quarters, the painting represents the culmination in Chinese art history of a growing fascination with eroticism. During the Ming dynasty, eroticism was generally sublimated, and most images were based on literary or semihistorical stories that could imbue them with greater respectability. Gradually sexual titillation became the direct subject of paintings restricted to male audiences (and the occasional courtesan). Later the conservatism of the second half of the Qing dynasty necessitated efforts to once again disguise openly erotic images, and this painting, now retitled *Three Figures in a Room,* was made respectable through a spurious association with *The Story of the Western Wing.*

ROMANTIC ENCOUNTERS and sexual passion are no more lacking in Chinese art than in the art of any other culture, although their representations may be less explicit and require knowledge of Chinese literature and Confucian decorum to decode. It is necessary to look beneath the surface; a painting described as political allegory, for example, may actually be a splendid romance. Once we learn the iconography of love, we can recognize a solitary woman and a plum tree as sexual longing, or two birds on a branch as a pledge of marital devotion. While romance in Chinese art is most often addressed through symbol, direct celebrations of the attraction between the sexes became a legitimate genre in the late Ming dynasty, when a new and open social climate tolerated romance, and even eroticism, as never before. At this time visual imagery in Chinese art reached full blossom, inviting the viewer to enjoy the romance and rewarding the effort of learning to read the rich vocabulary of love. ∽

Notes

Unless otherwise noted, all translations are by Jan Stuart.

1. Yao Dajuin, "Appendix III: The Pleasure of Reading Drama: Illustrations to the Hongzhi Edition of *The Story of the Western Wing*," in Wang Shifu, *The Moon and the Zither: The Story of the Western Wing*, ed. and trans. Stephen H. West and Wilt L. Idema (Berkeley: University of California Press, 1991), pp. 465–66.

2. Seminal articles on the topic include Wang Yao-t'ing, "Images of the Heart: Chinese Paintings on a Theme of Love," trans. Deborah A. Sommer, *National Palace Museum Bulletin* 22, no. 5 (November/December 1987): 1–21, and no. 6 (January/February 1988): 1–21; and the excellent studies by Ellen Johnston Laing, "Chinese Palace-Style Poetry and the Depiction of *A Palace Beauty*," *Art Bulletin* 72, no. 2 (June 1990): 284–95, and "Erotic Themes and Romantic Heroines Depicted by Ch'iu Ying," *Archives of Asian Art* 49 (1996): 68–91.

3. Laing, "Chinese Palace-Style Poetry."

4. Anne Birrell, trans., introduction to *New Songs from a Jade Terrace* (Middlesex, England: Penguin Books, 1982), pp. 1, 6.

5. See Jessica Rawson, *Mysteries of Ancient China: New Discoveries from the Early Dynasties* (London: British Museum Press, 1996), pp. 202–3, for discussion and illustration of the bricks.

6. Entry by Song Baiyin, *Nanjing Bowuyuan cangbao lu* (Catalogue of treasures of the Nanjing Museum), ed. Nanjing Municipal Museum (Hong Kong: Joint Publishing Co., 1992), pp. 259–61. The scholar Helmut Brinker speculates that more of these sculptures may have originally existed, "but the intolerant narrowness of posterior Confucian censorship may not have allowed them to survive." "The Concept of the Human Body in Chinese Art," in *Symbolik des menschlichen Leibes,* ed. Paul Michel (Berlin: Peter Lang, 1995), pp. 49–81, 63–64, 79 and fig. 12. See Lucy Lim, ed., *Stories from China's Past: Han Dynasty Pictorial Tomb Reliefs and Archaeological Objects from Sichuan Province, People's Republic of China* (San Francisco: Chinese Culture Foundation of San Francisco, 1987), pp. 127–30, plates 38–40, for the view that the kissing couples represent the joy of human intimacy.

7. Bai Juyi, "Song of Unending Sorrow," trans. Witter Bynner, in *Anthology of Chinese Literature*, ed. Cyril Birch, vol. 1 (New York: Grove Press, 1967), p. 269.

8. Wu Hung, *The Double Screen: Medium and Representation in Chinese Painting* (Chicago: University of Chicago Press, 1996), pp. 29–71.

9. See Wai-yee Li, *Enchantment and Disenchantment: Love and Illusion in Chinese Literature* (Princeton, N.J.: Princeton University Press, 1993), p. 61.

10. See Maggie Bickford, *Ink Plum: The Making of a Chinese Scholar-Painting Genre* (Cambridge, England: Cambridge University Press, 1996), pp. 54–60.

11. For a complete translation of the inscription and detailed study of the painting, see Ginger Cheng-Chi Hsu, "Incarnations of the Blossoming Plum," *Ars Orientalis* 26 (1996): 23–45.

12. Stephen H. West and Wilt L. Idema, ed. and trans., introduction to Wang Shifu, *The Story of the Western Wing (Xixiang ji)* (Berkeley: University of California Press, 1995), p. 3. See also Yao, "Appendix III," pp. 437–68.

13. Ibid., p. 5.

14. For this identification, see Saito Kikutaro, "The Yuan Blue and White and the Yuan Drama," *Kobijutsu,* 1967, nos. 18–19:59–74; Craig Clunas, "The West Chamber: A Literary Theme in Chinese Porcelain Decoration," *Transactions of the Oriental Ceramic Society* 46 (1981–82): 69–86. These authors claim that three characters that appear on the jar indirectly refer to *The Story of the Western Wing*, but the characters are not very clear. Moreover the imagery on the jar does not correspond with any securely identified illustrations.

15. Yao, "Appendix III," p. 444.

16. Wang, *Moon and Zither,* p. 192.

17. See James Cahill, "The Three Zhangs, Yangzhou Beauties, and the Manchu Court," *Orientations* 27, no. 9 (October 1996): 59–68, for a discussion of Yangzhou artists who specialized in "beauties."

18. James Cahill provided this information in personal correspondence dated December 1997.

19. Thomas Lawton, *Chinese Figure Painting: Freer Gallery of Art Fiftieth Anniversary Exhibition* (Washington, D.C.: Smithsonian Institution, 1973), p. 85.

20. Robert J. Maeda, "The Portrait of a Woman of the Late Ming–Early Ch'ing Period: Madame Ho-tung," *Archives of Asian–Art* 26, nos. 26–28 (1972–73): 46–51.

21. Laing, "Erotic Themes and Romantic Heroines," p. 85.

22. Ellen Laing, "Wives, Daughters, and Lovers: Three Ming Dynasty Women Painters," in Marsha Weidner et al., *Views from the Jade Terrace: Chinese Women Artists, 1300-1912,* (New York: Indianapolis Museum of Art and Rizzoli, 1988), p. 37.

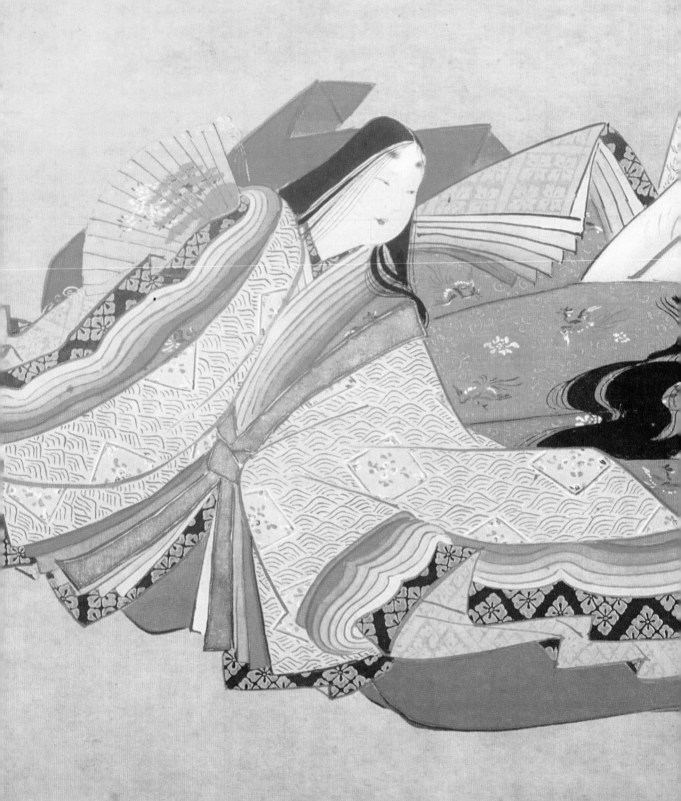

Oh, how I wish there was
one more meeting, now, with you!

PICTURING LOVE AMONG THE
ONE HUNDRED POETS

Joshua S. Mostow

Classical love poems from Japan tell of love denied, not love fulfilled. Most often composed to accompany letters, they followed a fairly set pattern. The man would initiate, declaring his love for the woman. If the woman was not interested in the man, she would refuse to answer with a verse of her own. If she wrote back, the man should consider himself encouraged to pursue his suit. Not that the words of the woman's poem would be in the least encouraging. In fact, it was conventional that the woman would take the man's original poem and purposely misconstrue it to suggest that his feelings were far from deep. Rarely do we find a Japanese poem celebrating a happy or fulfilled love—rather than poems of love, these are poems of longing *(koi)*. Accordingly, when poems and motifs from famous love poems were used for wedding gifts, women's robes, or other celebratory occasions, the artist was confronted with a challenge: how to turn something unhappy into something auspicious.

One collection often drawn on for such occasions was the *Hyakunin isshu,* or *One Hundred Poets, One Poem Each,* the best known of all anthologies of Japanese poetry. Put together by the famous poet and scholar Fujiwara no Teika (1162–1241) near the end of his life, it is a treasure-house of amatory verse. At least forty-eight of the one hundred poems were originally written as love poems (although only forty-three of them were so classified in the imperial anthologies from which Teika drew them) and many of the others were interpreted romantically by later readers.

In fact, over the course of Japanese history, artists and poets from an increasingly broad range of classes devoted themselves to interpreting the love and picturing the lovers of these poems. Naturally, their interpretations sometimes differed. And since Teika's collection brings together poems from the seventh through thirteenth century, even some of his interpretations may have differed from the way the poems were originally understood. For instance, the poem by Ukon (active mid-tenth

Detail, Kano Tan'yū, Michitsuna no Haha, 1662–69. See fig. 5

century), a lady-in-waiting to the consort of Emperor Daigo (reigned 897–930), originally appeared in a poem-tale called *Yamato Monogatari* (Tales of Yamato, ca. 950) with the following introduction:

> A certain gentleman promised Ukon time and again that he would
> never forget her. Nonetheless, he did forget her in time, and so Ukon wrote:

wasuraruru	Forgotten by him,
mi woba omohazu	I do not think of myself.
chikahiteshi	But I can't help but worry
hito no inochi no	about the life of the man who
woshiku mo aru kana	swore so fervently before the gods!

I do not know what his response was.[1]

As we know that Ukon actually sent this poem to her unfaithful lover, the most natural reading is to understand her tone as tongue-in-cheek: "You've abandoned me, but I'm not so worried about that. What I'm really worried about is what the gods are going to do to you, since you swore so fervently to them that you would never leave me." However, when this poem was anthologized almost one hundred years after it was written, around 1005, in the third imperial anthology, the *Shūi wakashū* (Collection of gleanings of Japanese poems), its prose introduction was eliminated and the poem was listed simply as "circumstances unknown" *(dai shirazu)*. This editorial change turned the poem from a sarcastic letter to an unfaithful lover into a soliloquy, or a poem written by the poet when she was alone. Robbed of its bite, the poem now seems to be the solitary thoughts of an abandoned woman still so in love with her fickle lover that she is more concerned about what the gods might do to him for breaking his vow than the pain he has caused her by breaking it. Since Teika drew all his poems for the *One Hundred Poets* from imperial anthologies, it is quite possible that he read Ukon's verse this way. In turn, later readers of the poems in Teika's anthology interpreted them in ways that may have differed from the poet's, or anthologist's, original intent.

The addition of illustrations to poetry compelled artists to visualize poets and lovers, thus providing visual evidence of variant readings. Such illustrations began to appear about the time *One Hundred Poets* was put together, but in connection with an earlier anthology, the *Sanjūrokkasen shū* or *Anthology of the Thirty-Six Poetic Immortals*, compiled by Fujiwara no Kintō (966–1041) around 1013. With the development of a new, realistic style of portraiture, called *nise-e*, or "resemblance pictures," in the mid-thirteenth century, artists created imaginary portraits of Kintō's *Thirty-Six Poets*, called *kasen-e*. In the beginning, of course, these paintings were made solely for members of the aristocratic class, but by the Momoyama period (1568–1615), samurai generals were commissioning *kasen-e* painted on wooden plaques as votive offerings, called *hengaku kasen-e*.[2]

Portraits of Teika's *One Hundred Poets* first appeared in the early seventeenth century, at the very beginning of the new Tokugawa shogunate. By mid-century artists of the Kano school, the school officially patronized by military leaders from the 1480s through the Tokugawa period (1615–1868), were illustrating this collection. The earliest extant Kano school production of portraits of the *One Hundred Poets* is a deluxe album by Kano Tan'yū

(1602–1674) and four members of his workshop: his younger brother Kano Yasunobu (1613–1685) and the disciples Kano Tsunenobu (1636–1713) and Kano Masunobu (1625–1694). Tan'yū was the first *oku eshi,* or official government painter of the Tokugawa shogunate. This album, now in a private collection, was formerly owned by the powerful daimyo Date family. All one hundred poets are painted in rich mineral pigment on silk, with an inscription of each poet's poem on the facing page opposite. Most scholars believe that this album was part of the deluxe bridal trousseau prepared between 1662 and 1669 for a young bride of the aristocracy who was marrying into the powerful Date clan.

From documentary evidence, we know that Tan'yū produced many versions of the *Thirty-Six Poets* and *One Hundred Poets* around this period. For example, he created at least two sets of votive plaques of the *One Hundred Poets* (1634, 1650)[3] and by 1659 had created a model for joint projects with Masunobu, Tsunenobu, and Yasunobu.[4]

In fact, several copybooks of the *One Hundred Poets* attributed to Tan'yū survive, and while none of them are believed to be in his hand, they preserve a plan for a *One Hundred Poets* album that is older than the extant Date album. Such copybooks were made by painters of the Kano school and passed from teacher to student so that succeeding painters could produce works in the orthodox Kano style and with the proper iconography. This method of transmission led to copies of copies of copies, each increasingly further away from whatever original painting or sketch they were based on. One copybook of *One Hundred Poets,* now in the Tokyo National Museum, seems to be very close to the original, however, and though later than the finished Date album, it may well represent Tan'yū's earlier plan for the visualization of the *One Hundred Poets.*[5]

Figure 1. Attributed to Kano Tan'yū, Murasaki Shikibu (left) and Izumi Shikibu (right), in the album *Hyakunin isshu gajō* (Pictures of the *One Hundred Poets*), Japan, Edo period, 1616–1868. Ink and colors on paper, remounted as an album, 30 x 20 cm. Tokyo National Museum

The Date album is clearly from the same source as the Tokyo National Museum version, and at least three-fifths of

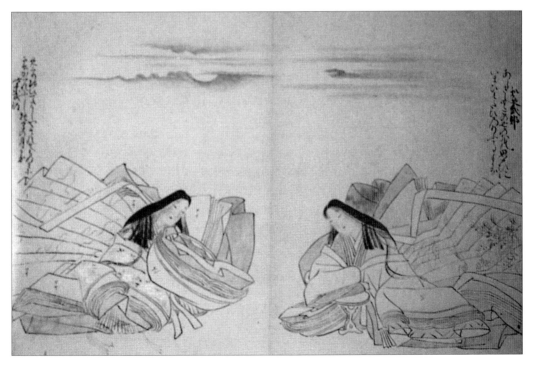

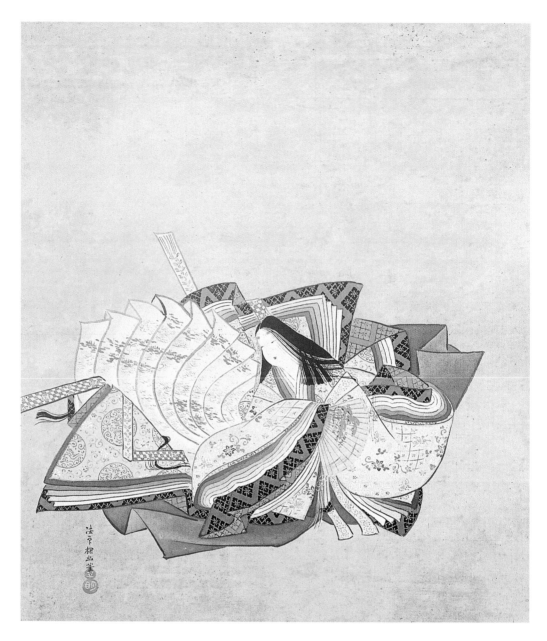

Figure 2. Kano Tan'yū, *Izumi Shikibu,* in the former Date family album *Hyakunin isshu gajō,* Japan, Edo period, 1662–69. Pigment on silk, 31.4 x 27.5 cm. Private collection

the portraits are identical. There are, however, three differences between the two works. First, while the Date album presents portraits of the poets against a plain background, the Tokyo National Museum version includes landscape and other elements directly related to the content of each poem. It is my belief that these background elements represent the first attempt to create visual representations of the poems themselves, a genre known in the Heian period (794–1185) as *uta-e,* or "poem-pictures."[6] Second, in several cases in the Date album, portraits from the Tokyo National Museum album are followed exactly but used for different poets; in other words, images are switched. For instance, the portraits for Sakanoue no Korenori (active late ninth–early tenth century) and Ki no Tomonori (died ca. 905) that appear in the Tokyo National Museum version are reversed in the Date album. Such reversals appear most often in the portraits attributed to Masunobu and Tsunenobu, the apprentices in the

production, who would be expected to follow most closely the designs of their master, Tan'yū. The third difference, and most important for discussion here, is that some portraits of poets in the Date album are completely different from those in the Tokyo National Museum version. These new portraits are most often the work of Yasunobu, who, as Tan'yū's brother, may have felt less constrained by the workshop hierarchy. However, there are also portraits in the Date album by Tan'yū himself that differ from those found in the Tokyo National Museum version, and it is in these changes that we can most clearly infer the difference in the kind of audience for which each work was created. Whereas the Date album was made for a young woman entering a politically charged, arranged marriage, the original Tokyo National Museum version was probably created with a male warrior in mind. Commissions from powerful men, such as the nobility, the shogun, and major military commanders, indicate that, increasingly, the possession of art and literature — a picture album of the famous *Tale of Genji*, for example — was perceived as a kind of cultural capital that enhanced political power.[7]

Not surprisingly, it is in the interpretation of the love poems that the difference between the two *One Hundred Poets* albums becomes most apparent. For instance, the verse by the famous female poet Izumi Shikibu (ca. 976–ca. 1030) reads:

arazaramu	Among my memories
Kono yo no hoka no	of this world, from whence
omohide ni	I will soon be gone,
ima hito-tabi no	oh, how I wish there was
afu koto mogana	one more meeting, now, with you!

The *Goshūi Wakashū* (Later collection of gleanings of Japanese poems, 1086) explains that this poem was sent by Izumi, when she felt she was near death, to someone's house. Over the centuries, most readers have assumed that the "someone" was her lover. In the Tokyo National Museum version (fig. 1, right side), Tan'yū indicates Izumi's ill health by showing her leaning on an armrest *(kyōsoku)*, a pose that here is the Heian equivalent of being on a sickbed. This visual representation of the poet's ill health is absent, however, in the Date album (fig. 2).

In the Tokyo National Museum version, Izumi is paired with Murasaki Shikibu (ca. 973–ca. 1025) (fig. 1, left side) the famous author of *The Tale of Genji*. Murasaki's poem reads:

meguri-ahite	As I was wondering
mishi ya sore tomo	whether or not I had seen it
wakanu ma ni	by chance,
kumo-gakurenishi	it became cloud-hidden,
yoha no tsuki kana	the midnight moon!

In Tan'yū's rendition, Murasaki and Izumi form bracketing mirror images, both with long strands of hair hanging over the shoulder, their hands in their sleeves, and their pleated trains fanning out behind them, the lines of which are intersected by a cloth band. Izumi's train is decorated with autumnal images of bush clover and pampas plumes — the latter

often taken in poetry as sleeves waving to beckon a lover. Murasaki's train is much less decorated, but it is embroidered with the motif of cherry blossoms, serving as a vernal contrast to Izumi's autumnal flora. Since this is a copybook, none of the patterns are drawn out in full, but here and there are notations indicating the colors that should be used. The basic coloring of the two figures is also complementary, with their red under-skirts and light blue inner robes. The same pairing of complementary images appears later in the album with the female poets Ise no Tayū and Sei Shōnagon, where the basic color scheme is green. Murasaki and Izumi are shown as in their early middle years rather than as young women; their long hair—a prized attribute connoting sexuality—disappears behind them.

Above Murasaki is the suggestion of a moon hidden behind the clouds. This poem appears in *The Collected Poems of Murasaki Shikibu* (*Murasaki Shikibu shū*, date of compilation uncertain) with the following explanation: "I met with someone I had known long ago as a child, but the moment was brief and I hardly recognized them. It was the tenth of the Tenth Month. They left as hurriedly as if racing the moon."[8] Most readers understood this friend to be a woman. One sixteenth-century commentary, however, thinks the person is Murasaki's male lover. And a modern scholar, Komashaku Kimi, has associated this poem with her belief that Murasaki Shikibu "felt love homo-erotically."[9] Certainly, with this last interpretation in mind, we might note that Tan'yū's two poets do seem to be gazing earnestly at each other (see fig. 1). Still, their pairing more likely derives from their shared experience of being famous writers living on the margins of the highest echelons of Heian court society.

What is perhaps more striking, however, is the figure that represents Murasaki in the Date album (fig. 3). It is a back view, a visual motif that can be traced to the earliest extant portraits of the Thirty-Six Poets, where it was used for the poet Ono no Komachi. By Tan'yū's time the back view had become a kind of cliché of a Heian period court lady. In the Date album, the figure lacks all individuality or character, reducing the woman who was perhaps the greatest prose writer in the history of the Japanese language to little more than a doll, emphasizing her beauty by hiding her face, and her sexuality through the powerful flow of her long black hair. Stunning as this image may be, pattern does not equal personality, and Murasaki has been made simply decorative. In contrast, the Tokyo National Museum version of Murasaki is full of character and individuality.

A similar change is wrought on Japan's first great diarist, a woman known today only as Michitsuna's Mother (ca. 937–995) (fig. 4, left side). Her poem was composed for her fickle husband after he complained about being kept waiting at her gate on one of his infrequent visits to her:

nagekitsutsu	The span of time
hitori nuru yo no	that I sleep alone, sighing,
akuru ma ha	until night lightens —
ika ni hisashiki	can you at all know
mono to ka ha shiru	how long *that* is?

Here again, a troubled, middle-aged woman is replaced in the Date album by a young bland cipher (fig. 5). In the Tokyo National Museum version, the figure suggests a certain

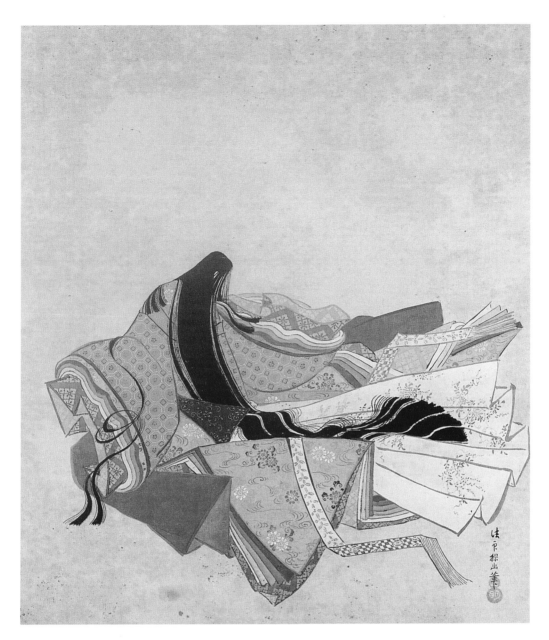

Figure 3. Kano Tan'yū, Murasaki Shikibu, in the former Date family album *Hyakunin isshu gajō*, Japan, Edo period, 1662–69. Pigment on silk, 31.4 x 27.5 cm. Private collection

power and intensity: her posture is upright, with her knees spread apart and planted within her *hakama*, or loose skirt-trousers. She focuses her gaze outside the picture plane, where we can imagine her husband standing. Geometric patterning, rather than floral motifs, decorate her clothing, echoing the architectural lines of the gate and wall above her. In contrast, the woman of the Date album is a young flirt, and while we can see vestiges of the original composition in her posture, her expression strongly suggests that we read her poem more as light banter than serious complaint.

Moreover, Tan'yū's original conception created a dialogue between Michitsuna's Mother and the preceding poet, Fujiwara no Michinobu (972–994), whose poem is illustrated on the right side of figure 4. This is a "morning after poem," sent to the woman with whom he had spent the night:

akenureba	Because it has dawned,
kururu mono to ha	it will become night again —
shiri-nagara	this I know, and yet,
naho urameshiki	ah, how hateful it is —
asaborake kana	the first cold light of morning!

Heian lovers typically left for home just before dawn to escape the notice of others. Michinobu complains that while he knows the dawn in fact brings the possibility of yet another evening of love, still he regrets having to leave the woman he is with. There is nothing in Michinobu's poem to require the wall that Tan'yū has depicted in the upper left of the drawing, but its addition establishes a relation to the portrait of Michitsuna's Mother, with a gate depicted in the upper left. And since we would read Michinobu's poem first and then Michitsuna's Mother's (the album is read from right to left), the pair function as a typical exchange of poems (*zōtōka*) between lovers in the Heian period. In other words, in the Tokyo National Museum version, Michitsuna's Mother is allowed to "talk back," while in the Date version the image implies the selfless isolation that some readers attributed to Ukon.

But the most striking example of this dilution of feeling from the Tokyo National Museum copybook to the Date family album is in the portrait of Imperial Princess Shikishi (died 1201), where a pretty and coy young girl (fig. 6) replaces a powerful portrayal of a deeply conflicted woman (fig. 7). Shikishi's poem reads:

tama no wo yo	O jeweled thread of life!
taenaba taene	if you are to break, then break now!
nagaraheba	For, if I live on,
shinoburu koto no	my ability to hide my love
yohari mo zo suru	will most surely weaken!

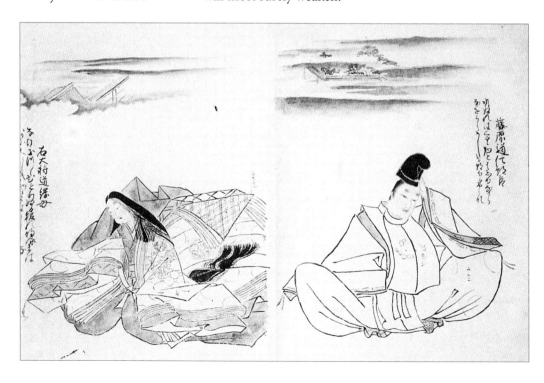

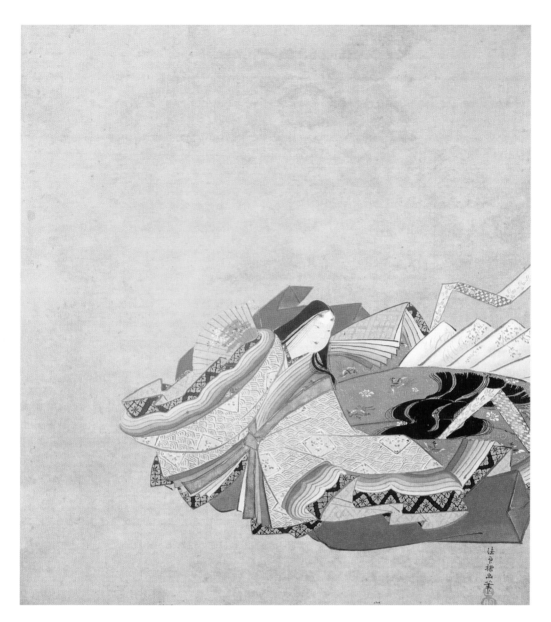

The Tokyo National Museum composition is nothing short of brilliant, showing us the anguished princess through her blind, revealing to the reader and viewer the very feelings she claims, in her poem, she wants to hide. The trappings due her imperial rank—the blind, the curtain, the twelve-layer robes, the mat on which she is sitting—in no way detract from her individuality. She gazes out intensely, as her robes slips from her left shoulder, exposing her thin singlet underneath. The framing lines of the blind seem barely able to contain the massive undulating lines of her clothing. In contrast, the Date album stresses both the woman's rank as an imperial princess—with the embroidered tatami mat reserved for the imperial family and her curtain of state—and her reputation as a poet, with what seems to be a sheaf of poems before her. Rather than expressing her emotional torment, her robes

Figure 4. Left: Attributed to Kano Tan'yū, Michitsuna no Haha (left) and Fujiwara no Michinobu (right) in the album *Hyakunin isshu gajō*, Japan, Edo Period, 1615–1868. Ink and colors on paper, remounted as an album, 30 x 20 cm. Tokyo National Museum.

Figure 5. Above: Kano Tan'yū, Michitsuna no Haha, in the former Date family album *Hyakunin isshu gajō*, Japan, Edo period, 1662–69, Pigment on silk, 31.4 x 27.5 cm. Private collection

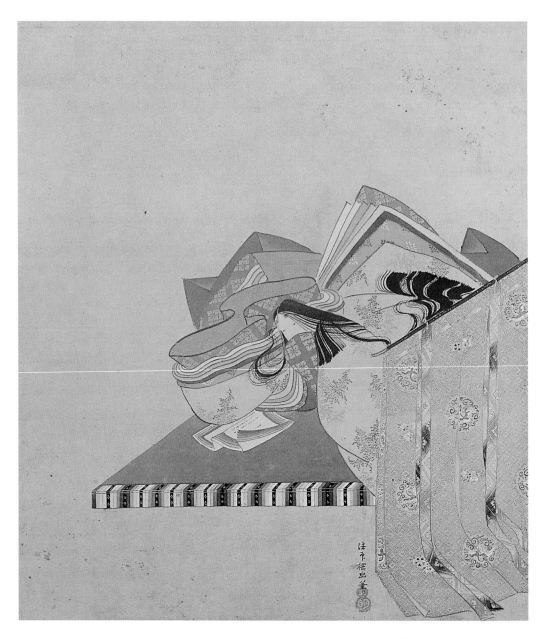

Figure 6. Kano Tan'yū, Shikishi
Naishinnō, in the former Date family
album *Hyakunin isshu gajō*, Japan,
Edo period, 1662–69. Pigment on silk,
31.4 x 27.5 cm. Private collection

now threaten to swallow her up, and the little we see of her face is lost between the graduated shading of her writing paper and the carefully matched corners of her robes. It is hard to believe that this woman has known true passion, and one suspects that her love poems are no more than literary exercises.

Thus, while the pathos of lost or unrequited love could apparently be depicted for a male reader, a very different representation was required for the Date album, which served as an educational text for dutiful daughters and young wives. As appropriate for young women heading toward politically motivated arranged marriages, the intensity and pathos of love poetry are blanched out, the potential for pain suppressed by elegant banter and literary fiction.

The differences between the albums involved more than the love poetry. Many portraits in the Tokyo National Museum version emphasize the poet's political role in history.

Thus Emperor Tenji (reigned 668–71) appears on a throne-chair and behind the upraised blind that usually hid the sovereign. The same blind is used for Empress Jitō (reigned 687–96) who was not just the wife of an emperor but a ruler in her own right. In the Date album, Empress Jitō peeps shyly over her fan, her writing box in front of her. Here it is Jitō as poet, not monarch, that is emphasized.

There is also a decidedly Chinese flavor to some of the figures in the Tokyo National Museum version. In the Heian as well as the Tokugawa periods, education by definition meant learning in Chinese and, especially in the later period, women were largely excluded from such study. The Tokyo National Museum's version of Ki no Tsurayuki (ca. 868–945) (fig. 8) allows the Chinese-educated male viewer to associate the Japanese poet with the Chinese verse so important to the educational curriculum for males. Tsurakuyi is given long, Chinese-style sidelocks, and a long chin beard, and his pose of holding the flowers, with his little finger pointing out, derives from Ming Chinese models. The result is an image closer to the Chinese poetic immortals Tan'yū depicted for the famous Shisendō of Ishikawa Jōzan (1583–1672) in Kyoto.[10] In the Date album, however, Tan'yū replaced this figure with one drawn from the standard Kano repertoire (fig. 9).

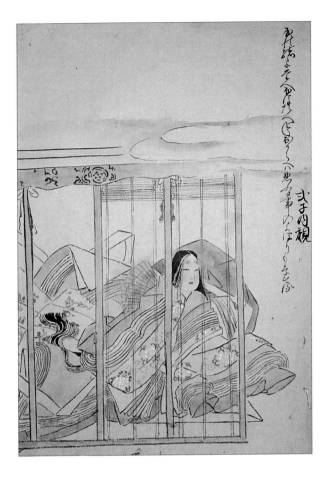

Figure 7. Attributed to Kano Tan'yū, Shikishi Naishinnō, in the album *Hyakunin isshu gajō,* Japan, Edo period, 1615–1868. Ink and colors on paper, remounted as an album, 30 x 20 cm. Tokyo National Museum

In sum, the Tokyo National Museum version of the *One Hundred Poets,* created for a male audience of the warrior class, emphasizes the political status of the poets depicted, the unhappy pathos of love, and a relationship to Chinese letters. These aspects are deemphasized or elimated in the Date album, which was made for a female audience of the aristocratic class. Women were apparently encouraged to appreciate poetry differently from men.

Although it is the Date album, rather than the Tokyo National Museum version, that is the finished work, through the practice of copybooks the latter was soon disseminated to a surprisingly broad spectrum of Japanese readers. By 1695 parts of it were parodied by the first famous woodblock print artist, Hishikawa Moronobu (died 1694). The year after his death, his son published Moronobu's *Fūryū sugata-e hyakunin isshu,* or *Elegant Figure Portraits of the One Hundred Poets, One Poem Each.* While this work claims to be for the edification of women and children and each poem is followed by a prose explanation, Moronobu's "illustrations" are in fact clever parodies of the original poems, setting them in his own Genroku era (1688–1704), among not only aristocrats but among samurai and

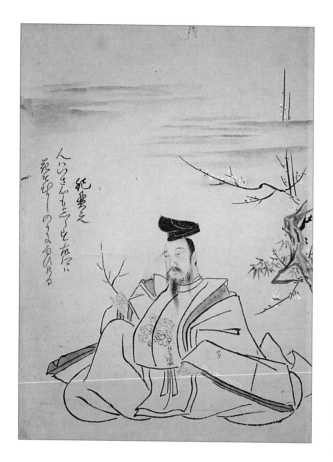

townsmen as well. Moreover, the entire collection is interpreted romantically, or erotically, and Moronobu's one hundred illustrations present us with a wide range and variety of romantic situations, including homosexual love.

The establishment of the Tokugawa warrior government in 1615 was accompanied by a wide acceptance of pederasty that also extended to the merchant class and led to the increase of homosexual prostitution. The practice of male homosexuality in this period was similar to that of ancient Greece: relationships were always between an adult man, called the "older brother," and a young man, or *wakashu*. *Wakashu* were adolescent males between about eleven and nineteen years of age, and their status was specifically indicated by their hairstyle: where adult men generally had a completely shaven pate and topknot, *wakashu* had only a small part of the top of their heads shaved, leaving their bangs, or forelocks, in place.[11]

These couples—a man and his younger lover—make their appearance in Moronobu's exhaustive array. For instance, Tsurayuki's poem reads:

hito ha isa	With people, well,
kokoro mo shirazu	you can never know their hearts;
furu-sato ha	but in my old village
hana zo mukashi no	the flowers brightly bloom with
ka ni nihohikeru	the scent of the days of old.

The circumstances of this poem's composition are described in the *Kokin wakashū* (Collection of ancient and modern Japanese verse, ca. 905):

There was a house of someone with whom the poet stayed whenever he made a pilgrimage to Hatsuse Temple. However, for a long time he did not have occasion to stay there. Time passed, and later, when he did finally visit again, the owner of the house sent out the following message upon his arrival: "As you can see, there is always a lodging for you!" Whereupon Tsurayuki broke off a branch of a plum tree that had been planted there and sent it in with this poem.[12]

As in Murasaki Shikibu's and Izumi Shikibu's poems, the question centers on the relationship between the poet and the recipient of the poet's verse. All early modern illustrations of Tsurayuki's poem show the owner of the house as a man, sometimes as another courtier, sometimes as a monk. While some Muromachi period (1333–1568) commentaries

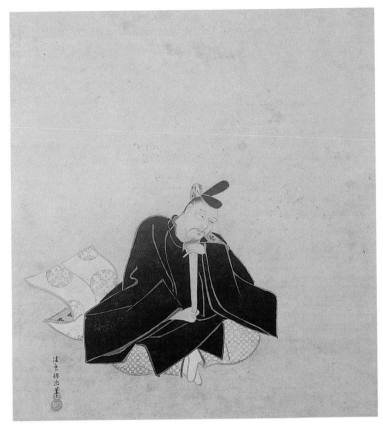

Figure 8. Left: Attributed to Kano Tan'yū, Ki no Tsurayuki in the album *Hyakunin isshu gajō*, Japan, Edo period, 1615–1868. Ink and colors on paper, remounted as an album, 30 x 20 cm. Tokyo National Museum.

Figure 9. Kano Tan'yū, Ki no Tsurayuki, in the former Date family album *Hyakunin isshu gajō*, Edo period, 1662–69. Pigment on silk, 31.4 x 27.5 cm. Private collection

intepret this poem romantically, they do not indicate whether they thought the owner was male or female. Nor is the poem included in the well-known anthology of male homoerotic poetry, *Iwatsutsuji* (Wild azaleas), put together by Kitamura Kigin (1624–1705) in 1676.[13] One modern scholar has explicitly suggested that the owner was a woman who was complaining of Tsurayuki's neglect.[14] However, in Moronobu's version (fig. 10), the poet is comparing the constancy of the plums (a traditional symbol of fidelity) to the young man before him, assessing the loyalty of the latter. Moronobu's figure clearly derives from Tan'yū's (see fig. 8), with the same distinctive holding of the branch, the same up-raised knee, the same suggestion of plum and bamboo in the background. While the reader unfamiliar with Tan'yū's version would still enjoy the joke of seeing Tsurayuki's verse rendered homoerotically, Moronobu must have been counting on Tan'yū's iconography being well enough known that some would recognize his deliberate send-up.

The shaved pate or crown of a *wakashu* was called the *sakayaki*, which was written with the Chinese characters for "moon" and a character that usually means "age" or "generation" or "replacement" or "substitute," because the shape of the pate was thought to resemble a moon. In a number of Moronobu's parodies, it is the young man's shaved crown that stands for the moon in the poet's song, as in his picture for the poem by Korenori (fig. 11):

asaborake	So that I thought it
ariake no tsuki to	the light of the lingering moon
miru made ni	at dawn —
yoshino no sato ni	the white snow that has fallen
fureru shira-yuki	on the village of Yoshino.

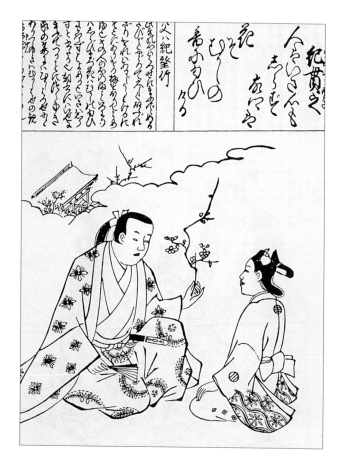

Figure 10. Left: Hishikawa Moronobu, Ki no Tsurayuki, in *Fūryū sugata-e hyakunin isshu* (Elegant Figure Portraits of the *One Hundred Poets, One Poem Each*) (Edo: Kinoshita Jin'emon, 1695), vol. 2. Woodblock print, 27.5 x 18.5 cm. Atomi Gakuen Tanki Daigaku Toshokan

Figure 11. Right: Hishikawa Moronobu, Sakanoue no Korenori, in *Fūryū sugata-e hyakunin isshu*, vol. 1. Woodblock print, 27.5 x 18.5 cm. Atomi Gakuen Tanki Daigaku Toshokan

Figure 12. Far right: Attributed to Kano Tan'yū, Kamakura Udaijin (Sanetomo), in the album *Hyakunin isshu gajō*, Japan, Edo period, 1615–1868. Ink and colors on paper, remounted as an album, 30 x 20 cm. Tokyo National Museum

Korenori's poem was not originally intended as a love poem. It describes waking up early in the morning in the isolated village of Yoshino and looking outside at the snow that has fallen overnight. The snow shines so brightly that the poet imagines for a moment it is not actually snow but the reflection of the moonlight on the ground. *Asaborake* refers specifically to dawn in either autumn or winter, and there is some disagreement among commentators as to whether the snowfall has been light or heavy. The commentary that accompanies Moronobu's picture opts for a light snow. In his picture, an aged Korenori is receiving a massage on his arm from a young woman, while a young boy massages his leg. The parody suggests that he is gazing at the *sakayaki*, or "moon-crown," of the young man before him, which, given its small diameter, appears to have been only recently shaved for the first time, comparing it implicitly with the beauty of the moon or perhaps the freshly fallen snow. A more careful reading, however, suggests that the man's gaze is turned rather on the young man's posterior and his fashionably tied waist sash. Regardless, Edo readers would have again appreciated the send-up of Korenori's verse, based on the association between the moon and "moon-crown."

Not all Moronobu's renditions are homoerotic, though most seem to be concerned with human passions. Many are parodies that assume that the viewer is familiar with Tan'yū's version of the poem depicted. We see this relationship in the pictures for the Kamakura period (1185–1333) shogun Minamoto no Sanetomo (1192–1219):

yo no naka ha	If only this world
tsune ni mogamo na	could always remain the same!
nagisa kogu	The sight of them towing
ama no wo-bune no	the small boats of the fisherfolk,
tsunade kanashi mo	who row in the tide, is touching indeed!

This is obviously not a love poem, and in the Tokyo National Museum album Tan'yū depicts the shogun in formal attire (fig. 12), with the boats at the top of the drawing. Moronobu parodies this depiction, showing the shogun in a far more relaxed state: hat off, his formal court sword replaced by a short *wakizashi*, and leaning on an armrest, while a young woman massages his shoulders (fig. 13). Again, as with Tsurayuki, half the fun of Moronobu's image is that it is based on Tan'yū's. There is a pun here as well, as the poem speaks of "fisherfolk," or *ama*, while the word for a masseuse is *amma*.

Moronobu's work seems to be created for a newly emerging class of affluent merchants and townspeople, along with superannuated samurai—the very group that also patronized the entertainment districts such as Yoshiwara and the Kabuki stage. The cultural center of this group soon became established in Edo (modern Tokyo), far removed from the lingering courtly shadows of the vestigial aristocracy. It is not surprising, then, that these new readers would hold the aristocrats, and especially the court ladies, at a remove, unassociated with the townspeople's own more earthly delights. This attitude is manifested in Moronobu's drawing for Princess Shikishi's poem (fig. 14). Gone is the emaciated, love-sick young woman; instead, we have a rather plump court lady, dressed in a

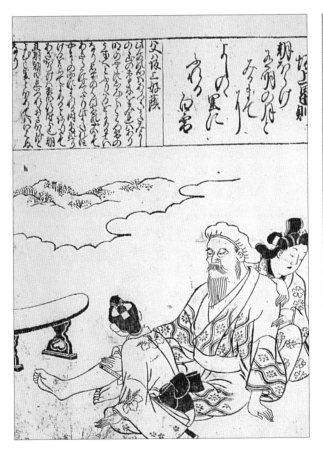

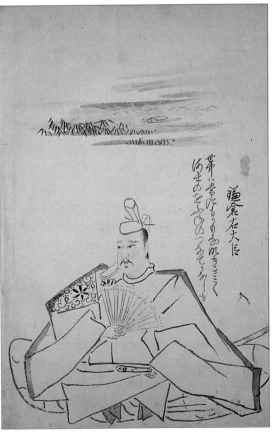

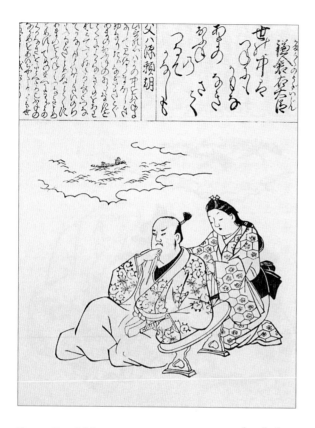

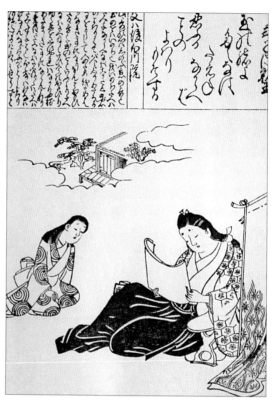

Figure 13. Hishikawa Moronobu, Kamakura Udaijin (Sanetomo), in *Fūryū sugata-e hyakunin isshu,* vol. 3. Woodblock print, 27.5 x 18.5 cm. Atomi Gakuen Tanki Daigaku Toshokan

Figure 14. Hishikawa Moronobu, Shikishi Naishinnō, in *Fūryū sugata-e hyakunin isshu,* vol. 3. Woodblock print, 27.5 x 18.5 cm. Atomi Gakuen Tanki Daigaku Toshokan

scarlet *hakama,* who seems to be agonizing about a sheaf of poems rather than any secret love, while a young female attendant commiserates with her. Ironically, then, this image for a new class of readers has more in common with the idealized images designed by Tan'yū for the aristocracy in the Date album than it does with the images in the Tokyo National Museum version, which were directed toward powerful military men who had close contact with the aristocracy.

THROUGH THE ARTISTIC renderings of these poets and poems, we can discern how the same poems were read differently by readers of different classes, times, and genders. While powerful military men saw the poets as similar to themselves — educated in the Chinese classics and experienced in the bitterness of love and politics — their women were encouraged to have a far happier view of love and to ignore politics. Later readers, both samurai and towns-folk, interpreted the same poems, sometimes in jest, and sometimes homoerotically, as we have seen in Moronobu's renditions. Japanese love poetry thus proves to be not only enduring but malleable enough to fulfill the desires of age after age of readers. ☙

Notes

Unless otherwise noted, all translations are from Joshua S. Mostow, *Pictures of the Heart: The Hyakunin Isshu in Word and Image* (Honolulu: University of Hawaii Press, 1996) and are reprinted by permission.

1. *Tales of Yamato,* trans. Mildred Tahara (Honolulu: University of Hawaii Press, 1980), p. 47. The translation of the poem is from Mostow, *Pictures,* p. 255.

2. Maribeth Graybill, "*Kasen-e:* An Investigation into the Origins of the Tradition of Poet Pictures in Japan" (Ph.D. diss., University of Michigan, 1983), pp. 176–182.

3. Shizuoka Prefectural Museum of Art, *Kaikan Sanshūnen Kinen-Ten: Kano-ha no Kyoshōtachi* (The Third Anniversary Exhibition: Great masters of Kano school) (Shizuoka: Shizuoka Prefectural Museum of Art, 1989), plates 40–41.

4. See Tokyo National Museum, *Tokubetsu-ten: Kano-ha no Kaiga* (Paintings of the Kano School) (Tokyo: Tokyo National Museum, 1979), plate 159; Yasumura Toshinobu, "Kanō-ha to Gajō" (The Kanō School and Albums), in *Tan'yū, Morikage, Itchō,* ed. Yasumura Toshinobu, vol. 4 of *Edo meisaku gajō zenshū* (Masterpieces of painted albums from the Edo period) (Tokyo: Shinshindō, 1994), p. 170; Mori Tōru, *Kasen-e, Hyakunin Isshu-e* (Imaginary poet portraits and One Hundred Poets pictures) (Tokyo: Kadokawa Shoten, 1981), p. 78.

5. Mori, *Kasen-e,* p. 78.

6. For more details, see Mostow, *Pictures of the Heart,* pp. 87–136; Mostow, "Painted Poems, Forgotten Words: Poem-Pictures and Classical Japanese Literature," *Monumenta Nipponica* 47, no. 3 (Autumn 1992): 342–44; Mostow, "*Uta-e* and Interrelations Between Poetry and Painting in the Heian Era" (Ph.D. diss., University of Pennsylvania, 1988).

7. See *Kokka* (Tokyo), no. 1222 (December 1997), a special issue on the *Tale of Genji* album in the collection of Harvard University Art Museums attributed to Tosa Mitsunobu, with articles by Chino Kaori, Kamei Wakana, and Ikeda Shinobu, and an English summary translated by Joshua S. Mostow.

8. Murasaki Shikibu, *Murasaki Shikibu: Her Diary and Poetic Memoirs,* trans. Richard Bowring (Princeton, N.J.: Princeton University Press, 1982), p. 217.

9. Komashaku Kimi, *Murasaki Shikibu no Messeeji* (Murasaki Shikibu's message) (Tokyo: Asahi Shinbunsha, 1991). See Mostow, *Pictures,* pp. 5–8. The sixteenth-century commentary was the *Minazuki Shō* (Minazuki commentary). See Mostow, *Pictures,* p. 310. On the structural "blindness" to female homosexuality in the Edo period, see Joshua S. Mostow, "The Structure of the Youngman *(Wakashu),*" in *Gender and Power in the Japanese Visual Field,* ed. Norman Bryson, Maribeth Graybill, and Joshua S. Mostow (Honolulu: University of Hawaii Press, forthcoming).

10. The Shisendō, or "Hall of Poetry Immortals," can still be visited in Kyoto. See also J. Thomas Rimer, Jonathan Chaves, Stephen Addiss, and Hiroyuki Suzuki, *Shisendo: Hall of the Poetry Immortals* (New York: Weatherhill, 1991).

11. See Mostow, "Structure of the Youngman *(Wakashu)*"; also Paul Gordon Schalow's translation of *The Great Mirror of Male Love* by Ihara Saikaku (Stanford: Stanford University Press, 1990).

12. Translation from Mostow, *Pictures,* p. 246.

13. *Wild Azaleas* is translated by Paul Gordon Schalow in Stephen D. Miller, ed., *Partings at Dawn: An Anthology of Japanese Gay Literature* (San Francisco: Gay Sunshine Press, 1996).

14. Ōoka Makoto, *Ki no Tsurayuki,* cited by Ariyoshi Tamotsu, *Hyakunin Isshu Zen Yakuchū* (Tokyo: Kōdansha, 1983), p. 153.

Like ground heat,
fierce, fierce —

JAPANESE LOVE POEMS

Hiroaki Sato

Over time love became a recurrent theme, explored imaginatively by poets in Japan. Indeed, the literary critic and poet Nakamura Shin'ichirō once characterized all the poems in the 1205 compilation *Shin kokin waka shū* (New anthology of Japanese poetry ancient and modern) as "love songs." The *Shin kokin shū* is the eighth of twenty-one imperial anthologies, and it contains 1,979 poems, every one of them written in the 5,7,5,7, 7-syllable tanka form.

Nakamura, a student of French literature, made this observation in promoting the view of the *Shin kokin shū* as the ultimate forum for the amatory infatuation of court poets of the day, and his notion may be too unorthodox for general acceptance. Yet in classical Japanese poetic tradition where categorization is of primary importance, *koi,* "love," is one of the six major categories, the other five being the four seasons and *zō,* "miscellany." Or, to go a step further, it is one of two categories if the four seasons are counted as one and "miscellany" is ignored, as is sometimes done.

Despite the categorical importance of "love," however, none of the anthologies compiled by imperial edict has anything comparable to the Song of Songs, as Nakamura noted. No court poet thought of "praising the swelling of his lover's breasts on the bed, delighting in the color of her lips, or becoming intoxicated by the heat of her thighs." Court poetry, in short, is a world where "the joy of sex is completely excluded."[1]

Detail, Takamura Chieko, paper collage, 1936–38. See page 64.

The Eclipse of Physical References

This was not the case before highly refined poetics took over, as may be clear from the following poem.

> Divine prince of eight thousand spears,
> because I am a woman, a pliant grass blade,
> my heart is a bird on the shore.
> Now I am my own bird,
> but later I will be your bird.
> Live on — do not ever die!
> This is the way the story's told
> by the low-running fisherman messenger.
> When the sun hides behind the green hills,
> night will come, black as leopard-flower seeds.
> Then, like the morning sun, come, smiling, blooming!
> These arms white as mulberry rope,
> breasts youthful as soft snow —
> hold them with your bare hands, caress them;
> your hand and my hand for a pillow,
> we'll sleep, thighs outstretched.
> So do not speak with too much love,
> divine prince of eight thousand spears.
> This is the way the story's told.

This poem, a *chōka* or "long song" attributed to Princess Nunakawa, appears in the *Kojiki* (Record of ancient matters), the semimythological account of Japanese history compiled in 712. It is a response she gives when Prince Ōkuninushi, "the deity of eight thousand spears," importunately pleads with her to let him into her room. That the poem was part of an ancient oral tradition is indicated by the incorporation of what is taken to be a medium's words, "This is the way the story's told."

But references to physicality quickly receded. By the time the first extant compendium of Japanese poetry, the *Man'yōshū* (Collection of ten thousand leaves), was compiled later in the eighth century, they had become rare and, where one occurred, much tamed. The following two poems, numbers 2,399 and 2,900, both tanka and anonymous, are typical:

> Although I sleep without touching your rosy skin, it isn't that I have
> changed my mind

> The smile, the eyebrows of my love vivid in my mind, I can't help
> thinking of her

And as physical references receded, so did a certain exuberance, although it did survive through the first few imperial anthologies, as we see in the following anonymous

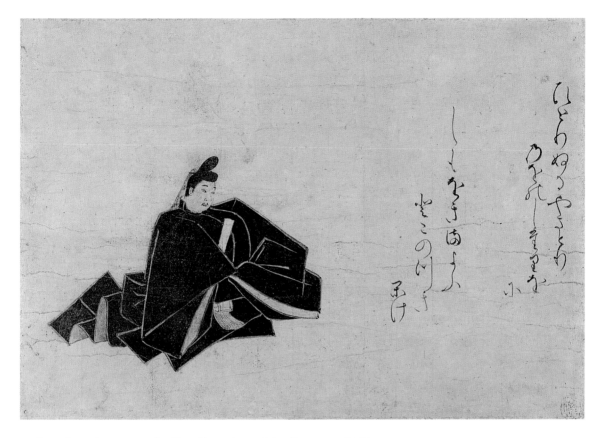

tanka selected to open the "love" section of the first one, *Kokin wakashū* (Anthology of Japanese poems ancient and modern).

Artist unknown, *Fujiwara no Teika*, Japan, Kamakura period, 14th century. Ink and light color on paper, 28.7 x 37.5 cm. Property of the Mary and Jackson Burke Foundation

> Cuckoos call, this is the Fifth Month with those irises,
> as profusely as those irises I'm in love!

Because, as is clear, I translate tanka in one line, and because translations of classical verse can greatly differ from one another, I should cite two other English renditions of this famous poem. Here is one by Laurel Rasplica Rodd, with Mary Catherine Henkenius, given in a 5, 7, 5, 7, 7-syllable, five-line format:

> When nightingales sing
> in the sweet purple iris
> of the Fifth Month
> I am unmindful of the warp
> on which we weave love's pattern

And how differently a poem can be rendered even using exactly the same format may be seen in another complete translation of the same anthology, by Helen Craig McCullough:

> This love has cast me
> into confusion as sweet
> as sweet flags growing
> in the Fifth Month, in the time
> when cuckoos come forth to sing.[2]

The allocation of 5, 7, 5, 7, 7-syllables is not standard in English translation, though the five-line format is.

Physicality and exuberance eventually yielded to such rarefied sophistication and stylization that the uninitiated would hardly recognize the anonymous poem that opens the "love" section of the *Shin kokin shū* as a "love song":

> Will I end up seeing it only from afar: white cloud on the peak of
> Mount Takama, of Kazuraki

This development did not, fortunately, mean the loss or rejection of immediacy in the canon, as the following poem may show.

> The night when, aggrieved, you sleep alone, you know how long
> before the day breaks

This poem, by Michitsuna's Mother (ca. 937–995), was originally in her *Kagerō nikki* (The gossamer memoir), and she composed it, she tells us, when her husband went off to visit another woman. But the poem was selected for inclusion in the third imperial anthology, *Shūi wakashū* (Anthology of gleanings), and in time became so canonical that Fujiwara no Teika (1162–1241), the great arbiter of matters poetic for his time and the generations of poets that followed, included it in his collection, the *Hyakunin isshu* (One Hundred Poems by One Hundred Poets—see "Picturing Love Among the *One Hundred Poets*" in this book). (The importance of "love" as a poetic subject is indicated by the fact that of these one hundred poems, forty-three are about love. Of the remaining poems, thirty-two are about the four seasons and twenty-five about "miscellaneous" topics.)

> String of beads, if you must break, break; if you last longer, my
> endurance is sure to weaken

If Michitsuna's Mother's poem was based on a real-life experience, this poem by Princess Shikishi (died 1201) shows that a poem need not be born of such experience to suggest immediacy. Composed on the conceit *shinobu koi*, "love to be endured," and for a sequence of one hundred poems that comes with detailed structural specifications, Shikishi's poem uses the somewhat obfuscating metaphor for life, *tamano'o*, "string of beads." For all the constraints, however, the poignancy of the poem was such that it created the sense that there had to be someone the poet was writing about, and some saw in that someone Fujiwara no Teika, who included it in his *Hyakunin isshu*. So was born the profoundly moving Nō drama *Teika*, attributed to Komparu Zenchiku (1405–1468).[3]

Nonetheless, at least one bodily part was exempt from the stern poetic decorum of the day: *kurokami*, "black hair," a court lady's prized possession:[4]

> *Nagakaran kokoro mo shirazu kurokami no midarete kesa wa mono*
> *koso omoe*
> Last long? I don't know his heart; my black hair in disorder this
> morning I can't help thinking

> *Kuromaki no midare mo shirazu uchifuseba mazu kakiyarishi hito to*
> *koishiki*

> Unaware of my black hair in disorder I lie; the one who first lifted it
> is the one I miss

> *Kakiyarishi sono kurokami no suji goto ni uchifusu hodo wa omokage*
> *zo tatsu*
> How I lifted her black hair strand by strand as I lie alone rises in my
> mind's eye

The first in this group is by the lady-in-waiting Horikawa. It is a *kinuginu,* "aubade" or "alba," a poem composed after the parting at dawn. The custom then was for a man to visit a woman in her abode during the night, and the poem, in a few strokes, captures the uncertainties of a woman left alone in the morning. Although her exact dates are unknown, Horikawa composed it as one of the twenty poems on "love," for a sequence of one hundred poems she submitted to Retired Emperor Sutoku (1119–1164), in 1150. It was then taken for the seventh imperial anthology *Senzai wakashū* (Anthology of poems for a thousand generations).[5] This is probably the most famous tanka on black hair for the simple reason that it is part of the canonical *Hyakunin isshu,* which even today many Japanese commit to memory because it is played as a New Year's game.

Horikawa in her poem alludes to the second poem in the group, which is by another lady-in-waiting, Izumi Shikibu (ca. 976–ca. 1030), who is famous for her love affairs. Allusion—of the kind and extent that would today immediately provoke cries of plagiarism—was then perfectly acceptable. In one of his treatises on poetics Fujiwara no Teika famously proclaimed: "To borrow as many as three units out of the five [that make up a tanka] is quite excessive and results in a lack of novelty; to borrow two units plus three or four syllables is admissible."[6] So, alluding to Izumi's poem, Teika himself wrote the third in the group.

So far I have cited only tanka, except for Princess Nunakawa's *chōka,* because for some unaccountable reason the early Japanese poets chose the tanka as the principal vehicle to convey their sentiments and the flexible, *chōka* form—it could combine three or more 5, 7-syllable units indefinitely—quickly lost its vitality. The small verse form of tanka, indeed, split into two units of the upper hemistich of 5, 7, 5 syllables and the lower hemistich of 7, 7 syllables, thereby spawning the verse form called *renga,* "linked verse," which was composed by two or more poets alternating the two units. What is today known as haiku was born when the opening unit of the *renga* sequence became independent.

These two new forms were heavily influenced by the finely binding poetics worked out for tanka. Consequently, even though "love" continued to play a distinct role in *renga* and haiku compositions, it is difficult to distill "love" from either poetic form—the *renga* because of its disjunctive linking and the haiku because of its brevity and certain conventions placed on it. This is why I neglect them here.

An any rate, the *chōka,* tanka, *renga,* and haiku were the only indigenous forms available to the Japanese poet at the end of the nineteenth century when new, flexible, and longer forms were created under the influence of the West. Fortunately, from the outset there was a totally different set of verse forms that Japanese poets could use: *kanshi,* or poems written in classical Chinese. Although Chinese is a language completely different from Japanese, some Japanese acquired facility in expressing themselves in the foreign

Rai San'yō, By the Rainy Window I
Spoke with Saikō About Parting,
Japan, Edo period, 1830. 136 x 47 cm.
Courtesy of Ema Sumiko

medium. So, here, let us look at three *kanshi* poets toward the end of the Edo period (1615–1868), when the genre was liberated from conventional topics and it became fashionable to describe daily occurrences, including the affairs of the heart, through it.

Three *Kanshi* Poets

> In my wretched street I trudge in the deep mud;
> a daybreak rain keeps falling like threads.
> Nearer home I feel all the more anxious,
> recognizing yet doubting my old house.
> My humble wife remembers my footsteps,
> becomes so overjoyed she appears sad.
> Returning for the first time in two years,
> my face is worn down from dust and dirt.
> She tries to heat water to wash my feet
> but the wood, being wet, is slow to burn.
> No, set aside the wet wood for a while:
> let's simply rejoice we're together again.

This is a poem Rai San'yō (1780–1832) wrote to describe his arriving back home, in Kyoto, early in the morning from two years' travels. San'yō, whose advocacy of the supremacy of the emperor over the shogun intoxicated generations of hot-blooded young men during much of the nineteenth century, also wrote exquisite poems about his wife, his mother, and his women friends. The reference here to wet chopped wood that is slow to catch fire in the oven is to suggest that the poet's wife, Rie, is pretending that her tears are from the smoke.

> *By the Rainy Window*
> *I Spoke with Saikō About Parting*
>
> In this detached room with a low lamp, stay awhile for fun;
> until the new mud on the way back dries, you better wait.
> On the other bank the peak and range have fewer clouds;
> in the next house strings and songs at night have peaked.
> This spring being intercalary, you, my guest, still stay,
> but night-long rain has pitilessly left few flowers intact.
> Mino for which you are about to leave isn't far away,
> but having grown old I expect it to be hard to meet often.

San'yō wrote this poem for Ema Saikō (1787–1861) in the spring of 1830 when she visited him. Saikō, an admired literati-painter, was San'yō's student in *kanshi*. They had met in late 1813 when San'yō visited her father and he, upon meeting Saikō, fell in love with her. But for some reason he could not muster the courage to ask for her hand and married his

own maid, Rie. Nonetheless, San'yō and Saikō remained close lifelong friends, perhaps lovers, with Saikō from time to time coming to see him in Kyoto all the way from Ōgaki, Mino (today's Gifu Prefecture), where she lived. "Intercalary" means "added to the calendar to make the calendar year correspond to the solar year." That year the third month was repeated. The poem describes a farewell party San'yō threw for Saikō.

Under the Pine Tree at Karasaki
I Said Farewell to San'yō Sensei

I stand on the shore; you are in the boat.
Boat and shore, facing, are tied by parting sorrow.
Gradually you fade into the lake haze, grow small,
and I blame the wind filling your sail.
Under the pine I linger, unable to leave,
but the expanse of blue waves is empty, vast.
I've parted with you seven times in twenty years,
but no parting difficult as this to explain to myself.

This is by Ema Saikō. The day after the farewell party described in the preceding poem, San'yō walked her as far as Karasaki, on Lake Biwa (six miles as the crow flies), and there, after parting with her, took a ferry elsewhere. The parting depicted here proved to be their last one; San'yō died two years later. *Sensei,* "teacher," is an honorific title.

This *kanshi* is one in a series of poems that Ōkubo Shibutsu (1767–1837) wrote after his wife's death. Nakamura Shin'ichirō has compared Shibutsu's literary sensibility to that of Jean Cocteau and Max Jacob.[7]

In the same bed you lay, back turned
as if a little upset about me;
I talked but you didn't respond.
Overcome, I tried to touch you,
and woke, a guest, a night's dream,
myself on the Eastern Sea shore.
How can I say you aren't to blame?
You left me, this gray-haired self,
not only this gray-haired me,
but who can our two girls rely on?
Yes, I, too, have made a mistake:
I've left them if only for a while.

Yosano Akiko and Her Black Hair

In 1901 Yosano Akiko (1878–1942)—who surely knew by heart the poems by Horikawa, Izumi, and Teika cited earlier—burst upon Japan's poetic scene with a book of tanka enti-

tled *Midare-gami* (Hair in disorder). And as befits the title, among the pieces declaring love in a manner that unabashedly proclaimed the arrival of a completely new era were many about her long black hair, of which she was very proud.

> Hair five feet, untangled, soft in the water; the maiden's heart I'll
> keep secret, won't let it out

> The girl twenty: flowing through the comb the black hair's arrogant
> the spring how beautiful

> He not allowed to go the darkening spring evening; laid on a small
> koto my tangled tangled hair

> Arm for pillow a strand of my hair snapped; I heard the sound as a
> small koto in spring night's dream

> My tangled hair back into a Kyō Shimada I shake him awake in the
> morning as he lies

> Receiving the spring rain dripping on swallow's wings I would
> caress my morning-slept hair

> Black hair, a thousand strands of hair, tangled hair, thoughts so
> tangled, thoughts tangled!

In translating the title of Akiko's book I gave *midare-gami* as "hair in disorder," remembering Robert Herrick's poem, "Delight in Disorder," which begins: "A sweet disorder in the dresse / Kindles in cloathes a wantonnesse." But it can also be "tangled hair," as I have rendered it in these poems and as some other translators have. In the fifth piece, Kyō Shimada is a style of hair normally sported by unmarried women.

> Not even touching the blood-tide in my soft flesh, aren't you lonely,
> you who teach the Way?

> Holding my breasts I softly kicked the door of mystery: here the
> flower's red is intense

> "Spring is short, how can life never perish?" I said, made his hands
> search my strong breasts

If Yosano Akiko's poetry overall captivated young men and women of her day, some of her poems, especially those that, like these three, directly depicted lust and sexual acts, scandalized influential men of letters. The fact that the man who taught "the Way," Yosano Tekkan (1873–1935), was her teacher of poetry and married, and that there was the involvement of another woman poet-student, Yamakawa Tomiko (1879–1909), probably did not help. The literary critic Takayama Chogyū (1871–1902), despite his espousal of romanticism, accused Akiko of "licentious sentiments and shallow philosophy," and Sasaki Nobutsuna (1872-1963), a poet and scholar of classical Japanese poetry, judged that

Takamura Kōtarō, *Head of Chieko*, Japan, Taishō period, ca. 1916. Plaster, measurements unknown (original lost during the Second World War). Courtesy of Takamura Hōshū

Midare-gami was "pernicious to the human heart and poisonous to social education."[8]

Such ethical judgments of the time notwithstanding, the hold of *Midare-gami* remains powerful a century later. The tanka poet Mizuhara Shion (born 1959), for one, has called *Midare-gami* "an epoch-making work that sought beauty by reaching a woman's deep [psychological] strata," concluding that it is "a collection of nightmares that reveal themselves at least once to the dullest and the most banal of women."[9]

Akiko married Tekkan as soon as his divorce was final, and they had thirteen children; she remained active in a range of literary endeavors and in women's education. Still, in 1938, when she was asked to edit a selection of her own tanka, she picked only fourteen out of the 399 pieces that made up the original book.[10] This may be partly because by then she had nearly fifty thousand tanka to choose from. But it may also be yet another case in which a poet's assessment of her own work differs from that of her readers, for today it is the rare person indeed who reads any of her tanka after *Midare-gami*.

Chieko: A Cycle of Poems

Lemon Elegy

So intensely you had been waiting for lemon.
In the sad, white, light deathbed
you took that one lemon from my hand
and bit it sharply with your bright teeth.
A fragrance rose the color of topaz.
Those heavenly drops of juice
flashed you back to sanity.
Your eyes, blue and transparent, slightly smiled.

You grasped my hand, how vigorous you were.
There was a storm in your throat
but just at the end
Chieko found Chieko again,
all life's love into one moment fallen.
And then once
as once you did on a mountaintop you let out a great sigh
and with it your engine stopped.
By the cherry blossoms in front of your photograph
today, too, I will put a cool fresh lemon.

The year 1938, in which Akiko edited a lifetime of tanka, saw the death of the most famous recipient of love poems in twentieth-century Japan — Chieko, the wife of the sculptor and poet Takamura Kōtarō (1883–1956). She died in a hospital where she had been committed more than three years earlier as a result of a schizophrenia that had made her dangerous to live with. The symptoms had begun to appear in the summer of 1931, so her death ended a struggle lasting for more than seven years, a struggle that involved her husband Kōtarō above all. But that is not the only reason that has since made "Lemon Elegy" so famous; this piece closed a rare cycle of poems describing a man's love for a woman.[11]

To Someone

No, no, I don't like it
your going away —

Like fruit coming before blossom
like bud sprouting before seed
like spring immediately following summer,
that's not logical, please don't do
so unnatural a thing.
A husband as if cast in a mold
and you with your smooth round handwriting,
the mere thought makes me cry.
You, who are timid as a bird,
willful as a gale,
you are to be a bride.

No, no, I don't like it
your going away —

How can you so easily,
how shall I say, as it were
put yourself on sale?
Because you *are* putting yourself on sale.
From the world of one person
to the world of ten thousand,
and yielding to a man,

yielding to nonsense,
what an ugly thing to do.
It's like Titian's painting
set out for shoppers in Tsurumaki-chō.
I am lonely, sad.
Though I really don't know what to do,
it's just like watching
the large gloxinia you gave me rot,
like watching it leave me and rot,
like seeing a bird fly off into the sky
not knowing where to,
it's the sad abandon of a wave as it shatters,
brittle, lonely, searing
— But it isn't love,
Santa Maria,
no, it isn't, it isn't.
I don't know what it is
but I don't like it
your going away —
besides you're going away to be a bride,
offering yourself to the will of a man you don't even know.

The cycle of "Chieko poems" began in 1912, with this poem. At the time Chieko was an aspiring painter, engaged to a physician back in her hometown. A few years before he met her, Kōtarō had returned from sojourns in New York, London, and Paris, where he studied sculpture, and he was brimming with "Western ideas," ready to denigrate most things Japanese. So you might say that in this poem, "To Someone," he was not expressing his love for her so much as objecting to her *miai kekkon,* "arranged marriage." If Chieko was a member of the feminist group called Seitōsha, "Blue Stockings' Society," and a New Woman, Kōtarō was a New Man. Tsurumaki-chō is a students' town near Waseda University, in Tokyo.

Lustful Hearts

Woman is full of lust.
I, too, am full of lust.
We, insatiate,
gleam with love and desire.

Utterly liberated, these lustful hearts.
This summer night
in the emerald black-lacquered air
that rises stiflingly,
turned into fish and bird we leap,
all unending.

Takamura Kōtarō, *Self-Portrait,* Japan, Taishō period, 1913. Oil on canvas, 61 x 44 cm. Courtesy of Takamura Tadashi.

We, both beyond the banal,
have already torn the net of standard rules.
The origins of our strength
are always in the chaos of Creation
and history, living in its fruit,
annihilates fear.
In consequence
the human world's harvests
gather in one spot before us,
our greatness fills the boundless expanse.

Lustful hearts thrust up our chests,
make us furious,
make us kowtow to all phenomena,
make our flesh and body fly,

and we utter a loud cry
and bathe in incomparable glory.

Woman is full of lust.
I, too, am full of lust.
Deepening our lust we don't know where to go.
All phenomena are held here.
We are full of more lust.
Like ground heat,
fierce, fierce —

Kōtarō and Chieko were married in 1914 and began an experiment of "two marital partners living on equal footing." And Kōtarō wrote a series of poems about their lives, some unprecedented in Japanese poetry. "Lustful Hearts" is one such poem, startling in its intensity and candor.

The One Who Hands Things
Over to the Imprisonment of Beauty

The red touch of the tax form is in my sleeve,
the cold night's wind, finally liberated from radio, is in the streets.

The irrationality of selling, those who can purchase are those who can own,
ownership is quarantining, the one who hands things over to the imprisonment
 of beauty, that's me.

The two don't go together, the supreme skills of plastic arts and the forcible
 exchange of coins,
the joy of creation and the bitterness of being unproductive and gluttonous.

Waiting for me in the vacant house are Chieko, clay, as well as wood chips,
the *taiyaki* cakes in my chest pocket, still faintly warm, crush.

Chieko and Kōtarō could not survive on love, sex, and dance. As artists, they were always hard pressed for money. Kōtarō had the notion that an artist, in the Western sense, should disdain sculpting for money — in contrast to his father, Kōun (1852–1934), who, at least in his son's eyes, was more an artisan than a sculptor[12] and therefore did not mind doing work for pecuniary gain. For her part, Chieko never submitted her artwork to a public forum after a painting of hers was turned down. Kōtarō describes their dilemma.

Chieko Riding the Wind

Chieko, now mad, will not speak
and only with blue magpies and plovers exchanges signs.
Along the hill-range of windbreak
pine pollen flows everywhere yellow and
in the wind of clear May, Kujūkuri Beach grows hazy.

Chieko's robe appears and disappears among the pines,
on the white sands there are truffles growing.
Gathering them, I
slowly follow after Chieko.
The blue magpies and plovers now are her friends.
To Chieko who has already given up being human
this terrifyingly beautiful morning sky is the finest place to walk.
Chieko flies.

Having a schizophrenic spouse, especially one prone to violence, was extremely difficult, as Kōtarō himself clinically detailed in some of his letters. But he never gave any hint of that in his poems; nor, except in "The One Who Hands Things Over," did he describe their domestic problems. As a result, Kōtarō was later faulted for beautifying his life with Chieko, with this poem as a prime example. Kujūkuri Beach is a long stretch of shore facing the Pacific Ocean directly east of Tokyo. After Chieko became insane, she was sometimes taken there for her health.

More seriously, recent critics have turned to accusing Kōtarō of driving Chieko into madness by selfishly pursuing his own art while neglecting—worse, deliberately stifling—Chieko's artistic aspirations, a point that is "proved" by the many beautiful paper collages that Chieko made once she was hospitalized and given sedatives.[13] In a series of poems satirizing famous modern poets through pastiches of their stylistic oddities and lines from their poems, Horiba Kiyoko (born 1930) has condemned Takamura Kōtarō by saying, in sum, "He just didn't get it."[14]

Kōtarō's role in Chieko's insanity, to a large extent, is moot. Aside from the view that schizophrenia is "almost surely a genetically based disease of the mind,"[15] we know so little about Chieko: that she tended to be withdrawn, easily hurt, and, after a certain point, prone to illness. All else we know derives from Kōtarō's reports overlaid with a sense of guilt. But Kōtarō cannot be blamed for feeling guilty: his wife was struck down by a mental disease whose cause was only vaguely understood at the time.

The most valid assessment may be the feminist scholar Komashaku Kimi's. She finds that Kōtarō was "a rare feminist of his day" who nobly struggled with an ideal but failed[16]—if indeed he failed.

Love as "Solitary Sadness"

Fish

In a dream
I was put on his supper table,
a broiled fish.
Though it was a supper with the whole family,
I was offered only to him
and I was steadily looking up at him

from the plate with an eye on one side.
He loosened the flesh on my back
that was a little arched
and when he finished eating the topside
picked me up by the tail to turn me over.
Each time his chopsticks touched me
I felt a faint pain, though a fish,
and when he picked me up by the tail
I was embarrassed
by my unseemly shape.
Soon
I was all turned into bones, like a small comb,

Takamura Chieko, paper collage,
Japan, Shōwa period, ca. 1936–38.
Paper. Courtesy of Takamura Tadashi

and I, a fish, was cold.

When I awoke and sat up
a pin like a delicate bone
gleaming blue slid down
from my nape perspiring a little.
When I buried my chin in the warmth of my collar
I smelled my warm smell.
And I, wondering
how I must have looked, a fish asleep,
and in the darkness of my bedroom shed a few tears.

Here is an example of poetry by Kikuchi Toshiko (born 1936) that offers off-center images of contemporary love, reflecting our consciousness that two persons in love are two separate beings. As Takahashi Mutsuo (born 1937) — who has written some dazzling poems on the theme of homosexual love — playfully concludes in a game of combining the many Chinese characters applied to the sounds *ko* and *i*, which make up the word "love," in the *Man'yōshū*, love may ultimately represent no more than "solitary sadness," the truism that "two persons in love are two separate beings."[17]

When Takahashi's book entitled *Nemuri to okashi to rakka to* (Sleeping, sinning, falling) was ready for publication in 1965,[18] Mishima Yukio (1925–1970) wrote an extravagant afterword, a lover's encomium really, where, recalling his friend's book published a year earlier, he said:

Mr. Takahashi was exempted from the human rule that every boy grows up to be a young man. It was a world where like the brilliance of the white salt in the saltern a marine product finally crystallizes and turns into a surface being, where he did not have to go down to the bottom of the sea, down to the bottom of the vagina which many a young man mistakes for a philosophy, mistakes for profundity.[19]

The book in question, *Bara no ki nise no koibito* (The rose tree, fake lovers), included the following poem:

Dream of Barcelona: My Ancient World

My Barcelona — the stone pavement shaded deep with weariness
The dry eyeballs are thrashed down
The surface of the stone begins to turn aslant
From there, flowing out in turmoil, darkly
Gradually giving forth luster, Diana's ocean
The ancient Mediterranean world
Wrapped in foam, from the bottom of heavy tides
Rising, growing clearer, bronze Hermes
A streak of light shouts on the dark half-face of this god of Hades
His profile devoid of the eye

A wide fig leaf covers

That part of his, once the shining center of fertility

Waves turn, coming closer, the voice of hard labor, of bitter rock salt

The salt, pungent, painful to the lips, the whips of burning heat, cruel to the
 young flesh

The galley with two decks of oars has sunk

The sunk plates, sunk slaves, sunk necks and armpit hair

The cry that disappeared, Silenus' vain song

Shadows, sailors, pass, the sea wind, Agrigentum

The turquoise sky between shattered colonnades

The island of palms and olives, the beach for wraiths

The wine that disappeared in the tideways

Rome, people swarming in the Forum

The thick eyebrows of young men selling melons

Jews selling dreams, Athenian male prostitutes

Crucified magnificent slaves, muscles twisting around the nails

Sunset, the wrestlers die

The sandals departed, the Colosseum in shadow

A breeze, the blood and mud greased on the coarse hair

High among their thighs, the fragrant areas wrapped with incense grass

Twin-horned ancient bulls lick the blood spilled on the ground

One of them cries sadly at the sky, the astrolabe

The bulls disappear, and the wrestlers

In my imagination, the ocean, Hermes' face of sorrow, spreads over the
 map of Rome

Near his ear, filing out of night's gate

Expeditionary soldiers in an interminable line

The road leads to the eight ends of the earth, the aqueduct spans heaven

Spears glint, in the dust, armor clangs

To Macedonia, to Numidia, and to Hispania, where the sun dies

Here, Hispania, the western limit of the printed map of the Roman Empire —

When I think of Barcelona, my dark flesh trembles

— Barcelona, the hidden gold

At the heart of this odd decadent labyrinth

The Ancient World is found unexpectedly innocent

Lamps come to reflect in the sweaty pavement

Two young men holding each other in the inn's stable straw

Under their soiled underwear, become armored Roman soldiers

Become one shining flesh

It may be appropriate to conclude this short survey of Japanese love poems with a
selection of tanka — the verse form sometimes described as the oldest poetic form in con-
tinuous use. The poet is Ishii Tatsuhiko (born 1952), who argues that "the tanka is a one-

line poem."[20] He has made the selection from a larger one in English translation, regrouping it as a sequence for this article and giving it a title:

Passing One-Night Love

Mediterranean nudes! I don't want to boast, no, but we are such an elegant tribe

Because he was born the day of solar eclipse the black skin of this black man hot as fire

(Love is just like wrestling) the way they love each other they appear ever so noble

Copulating we're all equally beast (whether they are men with golden hair or dark men)

That a man also has nipples makes you so sad when I bite one of them blood seeps

(The throat is another sexual organ) at a faint sound of gargling I prick up my ear

A man is a single duct (blocked by the arm of an angel burning like fire)

Smelling like some apocalyptic event in the dark lies the body of a man half asleep

So good are men in entanglement and dream (stored in their armpits is honey sweat)

If you are to die of love you should all the more because this is passing one-night love. ↷

Notes

Unless otherwise noted, all translations are by Hiroaki Sato.

1. Nakamura Shin'ichirō, "Iro-gonomi' no hensen," in *Nihon no mei-zuihitsu: Koi,* ed. Tanikawa Shuntarō (Tokyo: Sakuhin Sha, 1982), pp. 141–42.

2. Laurel Rasplica Rodd, with Mary Catherine Henkenius, trans., *Kokinshū: A Collection of Poems Ancient and Modern* (Princeton, N.J.: Princeton University Press, 1984), p. 183; Helen Craig McCullough, trans., *Kokin Wakashū: The First Imperial Anthology of Japanese Poetry* (Stanford, Calif.: Stanford University Press, 1985), p. 111.

3. The play, in English translation, is included in Hiroaki Sato and Burton Watson, eds., *From the Country of Eight Islands: An Anthology of Japanese Poetry* (New York: Anchor Books, 1981; reprint, New York: Columbia University Press, 1986), pp. 241–53.

4. "Black hair" is found in the *Man'yōshū* as well: e.g., no. 2631: "Her leopard-seed black hair spread out, her arm for a pillow, is my love waiting for me?"

5. Katano Tatsurō and Matsuno Yōichi, eds., *Senzai waka shū* (Tokyo: Iwanami Shoten, 1993), p. 243.

6. Quoted in Sato and Watson, trans., *From the Country of Eight Islands,* p. 202.

7. Nakamura Shin'ichirō, *Rai San'yō to sono jidai, Chū* (Tokyo: Chūō Kōron Sha, 1976), p. 311.

8. Both quoted in Hemmi Jun, *Aisuru koto to utau koto* (Tokyo: Bijutsu Hyōron Sha, 1986), p. 19.

9. Mizuhara Shion, *Hoshi no nikutai* (Tokyo: Shin'ya Sōsho Sha, 1995), pp. 82, 68.

10. Yosano Akiko, ed., *Yosano Akiko kashū* (Tokyo: Iwanami Shoten, 1943).

11. The American reader may be surprised to learn that the lemon here is a Sunkist product, a very expensive affair in prewar Japan.

12. Kōun's wood sculpture called *Old Monkey* won a grand prize in the Chicago World's Columbian Exposition in 1893. Kōun also made two of the best-known bronze statues in Japan: the equestrian one of the warrior-commander Kusunoki Masashige (1294–1336), which stands on the Imperial Palace grounds, and the one of the statesman Saigō Takamori (1827–1877), which is in Tokyo's Ueno Park.

13. Those who stress that Chieko used whatever scraps of paper she found around her to make those collages ignore the fact that the theory then was that such manual work was good for mental patients and that Kōtarō brought her *irogami,* "color paper" used for origami and other decorations.

14. Horiba Kiyoko's poem, "Takamura Kōtarō," cited in Shinkawa Kazue, ed., *Zoku: Onna-tachi no meishi shū* (Tokyo: Shichūsha, 1992), pp. 189–91.

15. Stephen Jay Gould, "This View of Life: The Internal Brand of the Scarlet," *Natural History,* March 1998, p. 72.

16. Komashaku Kimi, *Takamura Kōtarō* (Tokyo: Kōdansha, 1980), pp. 140, 200, et passim.

17. Takahashi Mutsuo, *Hana-asobi* (Tokyo: Ozawa Shoten, 1984), pp. 84–90.

18. Takahashi Mutsuo, *Nemuri to okashi to rakka to* (Tokyo: Sōgetsu Art Center, 1965), translated into English in toto by Hiroaki Sato, trans., *Sleeping, Sinning, Falling* (San Francisco: City Lights, 1992), pp. 5–35.

19. Quoted in Takahashi, *Nemuri to okashi to rakka to,* p. 81.

20. See Ishii Tatsuhiko, "Tanka no kōzō," *Luciole* 23 (December 1994), pp. 62–69, and "Rensaku no chikara," *Luciole* 24, pp. 46–53. *Luciole* is a magazine published by Shoshi Yamada, Tokyo.

Sources of the Poems

"Divine prince" is from Hiroaki Sato and Burton Watson, trans., *From the Country of Eight Islands: An Anthology of Japanese Poetry* (Anchor, 1981; reprint, New York: Columbia University Press, 1986), p. 5. The original of this poem is found in a wide variety of editions of the *Kojiki* and collections of "ancient songs," such as Tsuchihashi Yutaka and Konishi Jin'ichi, eds., *Kodai kayō shū* (Tokyo: Iwanami Shoten, 1957), pp. 36–37.

"Although I sleep" and "The smile" are from Takagi Ichinosuke et al. eds., *Man'yō shū, III* (Tokyo: Iwanami Shoten, 1960), pp. 169, 269.

"Cuckoos call" is from Saeki Umetomo, ed., *Kokin waku shū* (Tokyo: Iwanami Shoten, 1958), p. 200.

"Will I end up" is from Minemura Fumito, ed., *Shin kokin waka shū* (Tokyo: Shōgakukan, 1974), p. 309.

"The night" is from Hiroaki Sato, trans., *String of Beads: Complete Poems of Princess Shikishi* (Honolulu: University of Hawaii Press, 1993), p. 155. The translation is slightly revised for inclusion here. The original is found, for example, in Ariyoshi Tamotsu, ed. *Hyakunin isshu* (Tokyo: Kōdansha, 1983), p. 224.

"String of beads" is from Sato, trans., *String of Beads,* pp. 13, 104. The original is included in the *Shin kokin waka shū,* no. 1034. Teika was one of its editors.

"Last long?" is from Ariyoshi Tamotsu, ed., *Hyakunin isshu,* p. 332.

"Unaware" is from Kubota Jun and Hirata Yoshinobu, eds., *Go-shūi waka shū*, p. 246.

"How I lifted" is from Minemura Fumito, ed., *Shin kokin waka shū* , p. 418. In Teika's personal collection, *Shūi gusō,* it is no. 2507.

"In my wretched street" is from Nakamura Shin'ichirō, *Edo kanshi* (Tokyo: Iwanami Shoten, 1985), p. 153.

"By the Rainy Window" and "Under the Pine Tree" are from Hiroaki Sato, trans., *Breeze Through Bamboo: Kanshi of Ema Saikō* (New York: Columbia University Press, 1997), pp. 9–11. San'yō's original is in Kondō Hideo, ed., *Rai San'yō shishū* (Tokyo: Kondō Shuppan Sha, 1982), *p. 347;* Saikō's original is in Kado Reiko, ed., *Shōmu ikō ge* (Tokyo: Kyūko Shoin, 1994), p. 304.

"In the same bed" is from Nakamura, *Edo kanshi,* p. 170.

The poems by Yosano Akiko are from Sato and Watson, trans., *From the Country of Eight Islands,* pp. 431–33. The translations have been revised for this article.

"Lemon Elegy" is from Hiroaki Sato, trans., *A Brief History of Imbecility: Poetry and Prose of Takamura Kōtarō* (Honolulu: University of Hawaii Press, 1992), p. 119. The original is in Kitagawa Taichi et al., eds.,

Takamura Kōtarō zen-shishū (Tokyo: Shinchōsha, 1966), pp. 816– 17.

"To Someone" is from Sato, trans., *History of Imbecility,* pp. 93–94. The translation has been slightly revised for this article. The original is in Kitagawa, *Takamura Kōtarō zen-shishū,* pp. 770–72.

"Lustful Hearts" and "The One Who Hands Things Over" are from Kitagawa, *Takamura Kōtarō zen-shishū,* pp. 802–3, 810.

"Chieko Riding the Wind" is from Sato, trans., *History of Imbecility,* p. 115. The original is in Kitagawa, *Takamura Kōtarō zen-shishū,* pp. 811–12.

"Fish" is from Shinkawa Kazue, ed., *Zoku: Onna-tachi no meishi shū* (Tokyo: Shichō sha, 1992), pp. 94–95.

"Dream of Barcelona" is from Hiroaki Sato, *Poems of a Penisist* (Chicago: Chicago Review Press, 1975), pp. 14–15. The translation has been slightly revised for this article. The original is in Takahashi Mutsuo, *Takahashi Mutsuo shishū* (Tokyo: Shichōsha, 1969), pp. 22–24.

Ishii Tatsuhiko's selection is from Stephen D. Miller, ed., *Partings at Dawn: An Anthology of Japanese Gay Literature* (San Francisco: Gay Sunshine Press, 1996), pp. 297–308. The original poems are in Ishii Tatsuhiko, *Bathhouse* (Tokyo: Shoshi Yamada, 1994).

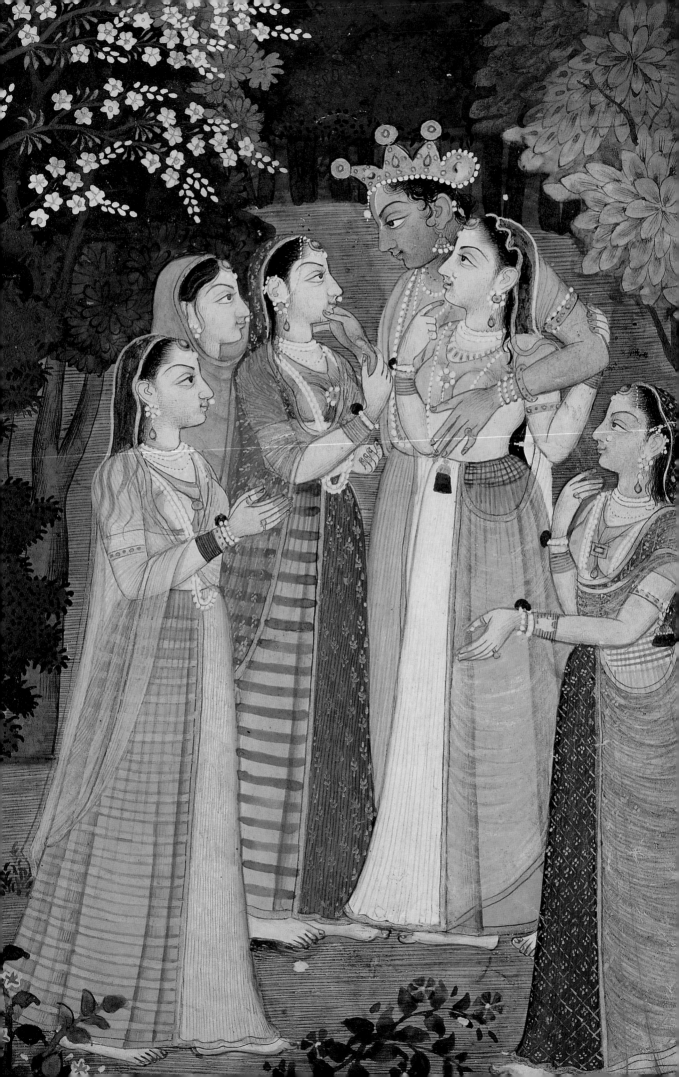

My heart values his vulgar ways

A HANDMAID'S TALE: *SAKHIS*, LOVE, DEVOTION,
AND POETRY IN RAJPUT PAINTING

Annapurna Garimella

A leaf from an eighteenth-century Kangra manu-
script of Jayadeva's lyric poem *Gita Govinda* (Love
song of the dark lord) depicts Radha tentatively
approaching her lover Krishna, the cowherd god, often
also invoked as Hari or Madhava (fig. 1). Before a dark
bower lit by his glowing body, Radha halts, one foot for-
ward, one foot back. A *sakhi,* her friend, gently enfolds
Radha, her other hand in the speaking gesture. They are
illustrating the last verse of one song from the *Gita
Govinda,* while Krishna, at the far right of the painting,
corresponds to the beginning of the next song, which is
in the *sakhi*'s voice. Here, as in the rest of the poem, the
sakhi mediates between Radha and Krishna, bridging
the two songs as well as the world of the painting and
its audience. The *sakhi,* which means "female friend" in
Sanskrit and other Indian languages, is a stock charac-
ter in romance literature; she functions as a go-between
and companion to the hero and heroine. Of the three
Gita Govinda verses inscribed on the back of the paint-
ing, the first is in the poet's voice, and he tells us of how
the *sakhi* unites Radha with Krishna:

Seeing Hari light the deep thicket
With brilliant jewel necklaces, a pendant,
A golden rope belt, armlets, and wrist bands,
Radha modestly stopped at the entrance,
But her friend urged her on.

Detail, *Krishna with Gopis and Radha with Sakhi,* in Jayadeva's *Gita Govinda,* ca. 1775. See fig. 4.

In the next two verses, the *sakhi* commands:

Revel in the wild luxury on the sweet thicket floor!
Your laughing face begs ardently for his love.
Radha, enter Madhava's intimate world!
Revel in a thick bed of red petals plucked as offerings!
Strings of pearls are quivering on your rounded breasts!
Radha, enter Madhava's intimate world![1]

Till this moment, the poem and paintings spoke of the jealousy, infidelity, and remorse of two lovers in separation.

Radha and Krishna are inhabitants of Brindavan town, and as members of the cowherding caste, go out daily to the pasture with their herd and return in the evening. On one spring *(vasanta)* day, Nanda, Krishna's stepfather, asks the older Radha to accompany young Krishna home through the dark forest, as he is frightened. Once they enter the forest, the situation is inverted, and Krishna seduces a tremulous but willing Radha and makes love to her. After this first encounter, the couple experience a series of misunderstandings and doubts, which a *sakhi,* their good friend, helps to resolve. Toward the conclusion of the *Gita Govinda,* the *sakhi* finally unites the lovers. Having previously seen, read, and listened to this well-known story, eighteenth-century viewers would have readily identified with the *sakhi*'s final act of diplomacy, which is presented in this painting.

Figure 1. *Radha, Enter Madhava's Intimate World,* from part 11, "Blissful Krishna," of Jayadeva's *Gita Govinda,* India, state of Kangra, ca. 1775. Opaque watercolor and gold on paper, 17.1 x 27.3 cm. Collection of Alvin O. Bellak

In another painted manuscript of the story (fig. 2), an elegantly dressed woman silently walks to meet her lover. Only partly inside the oval frame is a *sakhi,* head turned but hand

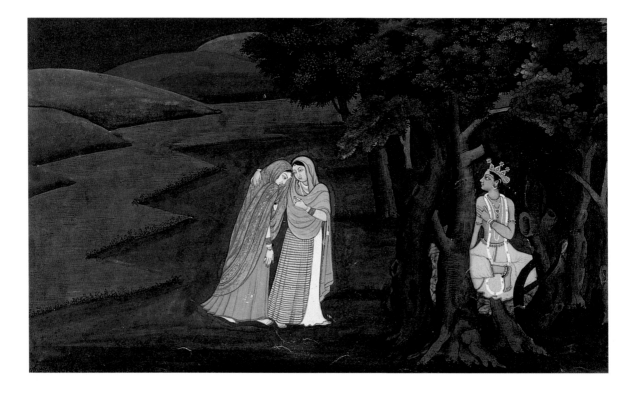

Figure 2. *Heroine and Sakhi in Moonlight,* from Bihari's *Satasai,* India, state of Kangra, Punjab Hills, ca. 1780–90. Opaque watercolor and gold on paper, 20.3 x 14.0 cm. Collection of Doris Weiner

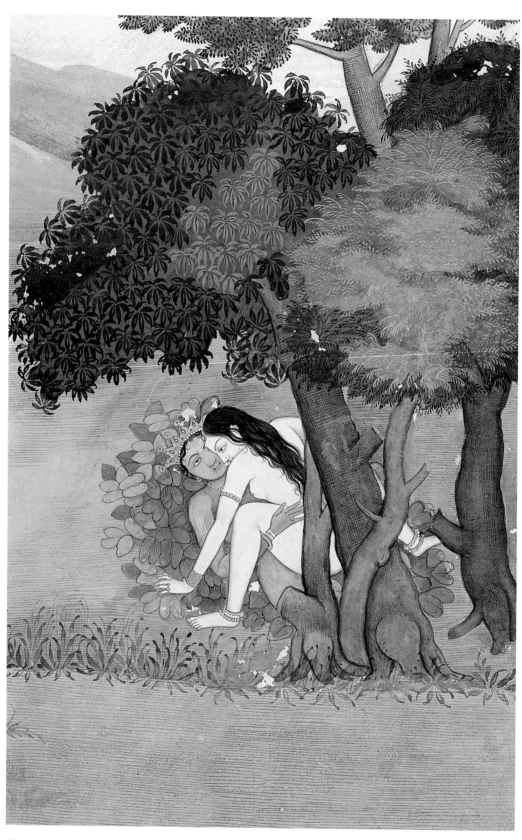

Figure 3. *Krishna and Radha's Imagined Rival Make Love,* from part 7, "Cunning Krishna," of Jayadeva's *Gita Govinda,* India, state of Kangra, ca. 1775. Opaque watercolor and gold on paper, 19.8 x 12.0 cm. The Robbins Collection of the Indian Princely States

pointing toward the heroine. The page is from an eighteenth-century Kangra manuscript of the *Satasai* (Seven hundred verses), written in the Braj language by the seventeenth-century North Indian court poet Bihari. A single verse inscribed on the back reads:

> The young woman disappeared in the moonlight, she was invisible to the eye.
> But hanging on the thread of her fragrance, the beelike sakhi followed her.[2]

Both painting and verse focus on the beautiful heroine, whom we recognize because she is centrally positioned on the page. But her companion, the beelike *sakhi,* is equally important: for the viewer, her actions identify the particularity of the woman who trysts by moonlight. This heroine hides herself by dressing in white to blend into the silvery moonlight. The *sakhi*'s hand toward her nose signifies the heroine's fragrance and her invisibility, while the other hand's gesture reveals the heroine.

When looking at Rajput love paintings, a viewer may initially puzzle over the identity of the various women. A descriptive title, such as *Radha Pining in Separation from Her Lover,* most often based on scholarly usage rather than a painting inscription, fails to account for the others present in the pictorial space. Equally perplexing is the almost complete absence of corresponding male figures. If a painting has a male, it is either Krishna or occasionally a king. For historians interested in precolonial conceptions of gender and class, particularly women's status, these love paintings are intriguing because they say so much more than art-historical scholarship and popular coffee-table books allow. Indeed, the radical dispersal of individual folios from painted manuscripts, especially those that deal with love, contributes to their problematic status. Many *Gita Govinda* folios, especially the more explicit lovemaking scenes, have been reframed in this century, either by dealers who actually recut them or by publishers who reproduce these paintings with strategic amputations (fig. 3). "Excess" trees, open landscape, figures, and buildings are excised, incidentally mutilating the verse on the back, violating the poem's narrative, and trapping the figures in a telescoped, erotic snapshot. These snapshots are regularly featured in the "art-porn" genre of palm-sized editions, produced to attract impulse purchasing in bookshops throughout the world and as souvenirs at famous temple sites in India.

To understand the ideas that Rajput art communicates about the gendered body, devotion, love, sex, and poetry, we need to reframe these paintings, seeing them as illustrations to a category of texts that were not, in their own day, devalued. The marginal women who populate the pages are a place to begin. Though ubiquitous, *sakhi*s have not been understood as being important, either within the dynamics of the narrative or within the composition of the painting. Hence, "A Handmaid's Tale."

Painted Leaves of the *Gita Govinda*

The *Gita Govinda* is a twelfth-century lyric composed by Jayadeva, a court poet from northeastern India.[3] The poem of twenty-four songs exults in Radha and Krishna, viewed not just as deities but as two intense, earthly lovers, fully subject to split-second jealousies, excessive pride, and hair-raising passion. Incorporating language and situations from the

established genre of erotic taxonomies describing lovers, love situations, and go-betweens, Jayadeva combined complex metaphors and rhetorical structures with oral poetry and folk songs to create an aesthetic and emotional response *(rasa)* in his audience.

Before Jayadeva, Krishna had appeared in epic and Sanskrit court poetry as a great ruler and friend. Occasionally there were references to his status as a divine lover who indulged in love-sports with his *gopis*, the Braj cowherd girls. Jayadeva transformed the Krishna story by isolating Radha as his primary lover, relegating the other *gopis* to the status of rival or, more important, assigning them the role of *sakhi.* Soon after its composition, the *Gita Govinda* became the foundational text of the Krishna devotion *(bhakti)* movements that were widespread across North India by the sixteenth century. Centered in Braj, the region around the towns of Agra, Mathura, and Brindavan, these movements exalted a personal relationship with Krishna. Court poets, wandering bards, theologians, and saints used the metaphors and emotions Jayadeva coined, writing sometimes in Sanskrit and sometimes in a regional Hindi called Brajbhasa. Highly esoteric aesthetic theories were formulated to encourage an ecstatic and emotional participation in Krishna and Radha's passion, especially through the role of *sakhi.* The *sakhi* was theologically justified as one in a group of devoted friends who performs labors of love. Although it is unlikely that artists, patrons, and viewers of Krishna-Radha paintings were always devotees, the philosophy of *sakhi*-based worship was widespread in North India, and the meaning of a twelfth-century poem was heightened by the prevalent religious climate of their own times.

The *sakhi*'s voice in the *Gita Govinda* is clearly entwined with Jayadeva's; both seek to unite Radha and Krishna. To describe Krishna's condition to Radha, the *sakhi* becomes sympathetic to his misery and conveys his longing to Radha. She also brings Radha to Krishna, using her *sakhi* relationship with Radha to act as go-between for Krishna. The *sakhi* recounts the couple's mutual suffering: her voice oscillates between first-person and third-person narrative to convey the lovers' passion with the observer's distance.[4]

Just as the *sakhi* describes Krishna's pitiful condition to Radha, Jayadeva, too, sings of Krishna's desolation. Throughout the poem, Jayadeva as *sakhi* communicates with both Radha ("Wildflower-garlanded Krishna suffers in your desertion, friend") and the listerner-reader-devotee ("When your heart feels his strong desire, Hari will rise to favor you"). As the listener's *sakhi,* he informs us of the affair in progress while also making the love happen. By identifying with Krishna's misery, Jayadeva opens the way for the listener-reader to become Krishna's messenger.

Artists who painted the circa 1775 *Gita Govinda* manuscript from the North Indian Pahari Hills court of Kangra maintained Jayadeva's structure, using a *sakhi* to present love in separation. Although it is impossible to be absolutely certain, as the manuscript is widely dispersed and some pages are missing, it seems likely that each page was matched to an appropriate verse. Sometimes one painting covered an entire song; sometimes it accompanied a single verse. In the process of designing the manuscript, artists interpreted the text, using a *sakhi* to heighten the mood of love in separation. Pages from this 1775 Kangra *Gita Govinda* manuscript (see figs. 1 and 4) reveal how the artists interpreted the text through the *sakhi,* creatively placing her in the pictorial space and giving her gestures that allow her to direct the meanings embedded in the text and so engage the audience.

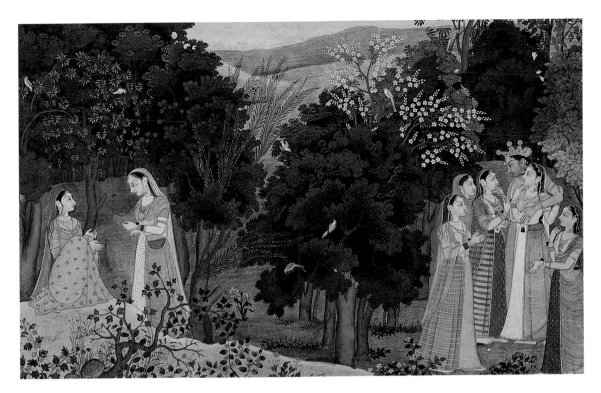

One folio from the 1775 *Gita Govinda* set illustrates two verses, only one of which is inscribed (fig. 4). Krishna stands to the right surrounded by women, each straining for closer contact. Two *sakhi*s stand slightly apart from the others: the one on the outer left joins her hands in prayer, the other stares in wonder. At the extreme left, Radha laments to another *sakhi* about her traitor heart, which longs for Krishna though she knows he is dallying with other women. Standing before Krishna, the praying *sakhi* signals to the viewer that devotion is one appropriate attitude. The wondrous *sakhi* draws the viewer's attention to Krishna even as her hand points ambiguously to both him and Radha. Her equivocating gesture allows the viewer's sympathies to move among Krishna's pleasure, the women he caresses, the *sakhi*'s wonder at his beauty, and the plight of Radha's longing.

Figure 4. *Krishna with Gopis and Radha with Sakhi*, from part 2, "Careless Krishna," of Jayadeva's *Gita Govinda*, India, state of Kangra, ca. 1775. Opaque watercolor and gold on paper, 18.3 x 28.2 cm. Collection of Gursharan and Elvira Sidhu

The painting is a brilliant continuous narrative combining two verses. One is the opening verse of the song, and the other is the end verse. The uninscribed opening verse, which inspired the right half of the painting, reads:

While Hari roamed in the forest
Making love to all the women,
Radha's hold on him loosened,
And envy drove her away.
But anywhere else she tried to retreat
In her thicket of wild vines,
Sound of bees buzzing circles overhead depressed her —
She told her friend the secret.

The inscribed end verse, placed on Radha's lips, reads:

My heart values his vulgar ways
Refuses to admit my rage
Feels strangely elated,
And keeps denying his guilt.
When he steals away without me
To indulge his craving
For more young women,
My perverse heart
Only wants Krishna back.
What can I do?[5]

Positioning both Radha and Krishna on the same page, but at opposite ends, the artist interprets her emotions in the context of his infidelity. This synchronicity, implied by the poet Jayadeva, is exploited by the artist to enhance the mood of separation and anger. The viewer follows the *sakhi* who, unlike her friends, has relinquished her own desire for Krishna's graceful touch and crossed the barrier of trees to listen to Radha's sorrow.

Figure 5. *Krishna Alone on a Hillock,* from part 5, "Lotus-Eyed Krishna Longing for Love," of Jayadeva's *Gita Govinda,* India, state of Kangra, ca. 1775. Opaque watercolor and gold on paper, 17.5 x 27.2 cm. The Robbins Collection of the Indian Princely States

In this leaf, the female figures are all alike. While Krishna has a distinctive blue body, Radha is not specially marked by either dress or physiognomy and is identified only by her placement in relation to the other figures. The devotee-viewer, desiring religious rapture, may experience Krishna as Radha, who wants him all to herself, or as one of the unnamed *gopis* who surround him. The viewer could empathize with Radha and

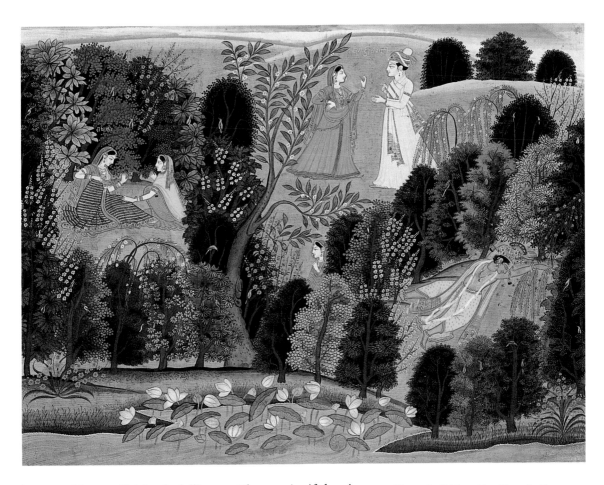

Figure 6. *Krishna Lies Alone in the Forest Pining for Radha,* from part 5, "Lotus-Eyed Krishna Longing for Love," of Jayadeva's *Gita Govinda,* India, state of Kangra, Punjab Hills, principality of Lambagraon, India, ca. 1825. Opaque watercolor and gold on paper, 24.5 x 31.7 cm. Collection of Jagdish Bhagwati and Padma Desai

her anguish over Krishna's dalliances. Then again, if the viewer chooses to be a *gopi,* then jealousy (why is Radha so special?) could be another reaction. Alternatively, the viewer may identify with Krishna, who does not appreciate or treat Radha any differently from the others. After all, at this moment in the narrative, Krishna revels in being the object of every woman's ardor. The utility of *sakhi* as a mediator is further established in scenes of Krishna's lovemaking with a single woman, where a *sakhi* rarely mediates between him and Radha (or the other woman). Whenever Krishna and a woman are represented together, the viewer knows to identify her as his sole beloved, whether she is Radha or Radha's fantasy of her rival. The artist allows Krishna's sultry yet penetrating gaze to interact directly with the viewer, offering communion in his mood of ecstacy (see fig. 3).

In figure 5, the painter depicts Krishna alone, and though bees — the messengers of love who signify its relentless demands — hover over his garlanded body and hum for his attention, it is all to no avail. Krishna's pictorial isolation emphasizes his regret. Earlier, he sent a *sakhi* to Radha to inform her of his agony. As we recite the verse inscribed on the back, we become Krishna's *sakhi:*

Bees swarm, buzzing sounds of love,
Making him cover his ears.

Your neglect affects his heart,
Inflicting pain night after night.
Wildflower-garlanded Krishna
Suffers in your desertion, friend.[6]

An 1825 painting of the same song employs another tactic, and the viewer's relation-
ship to Krishna's pain is subtly altered (fig. 6). Instead of choosing to represent a single
verse or combination of verses, the artist has produced a single painting for the entire
song. Beside the Yamuna, which flows at the bottom, lies Krishna pining on his bed of
leaves. Leaving his isolated bower, the *sakhi* steps toward Radha's grove and is shown again
at the extreme left, conversing with Radha, who listens with reluctance. At the top center
are two figures, a male and another female, with the label *varadi ragini* above them.
Jayadeva wrote this song in *varadi,* a feminine musical mode *(ragini)* that evokes the mood
of amorous desire in separation; ideally, the song must be performed in *varadi.* The female
ragini is always portrayed as a woman who holds off her lover. Here the lover is not a rustic
Braj cowherd; rather, his fine dress speaks of his status, and his gestures indicate his refine-
ment as a *rasika* (aesthete and connoisseur). The *ragini* and the nobleman physically
occupy a different section of the page, interacting with each other and not with the figures
below. But the artist has kept faith with Jayadeva. The female singer, too, is a *sakhi* helping
us have access to Krishna's desolation.

This page offers remarkable testimony of how the con-
temporaneous audience of Kangra aristocrats related to the
mythical time of the *Gita Govinda.* When the poem was sung
and the painting viewed, Krishna's world became localized in
the Kangra court. Paradoxically, the personified *ragini* and her

Figure 7. *Jayadeva's Vision of Radha
and Krishna,* from part 12, "Ecstatic
Krishna," of Jayadeva's *Gita Govinda,*
India, state of Kangra, ca. 1775. Opaque
watercolor and gold on paper, 16.5 x
26.7 cm. The Kronos Collections

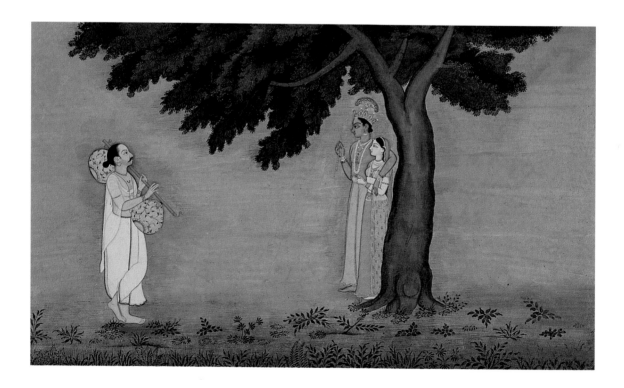

aristocratic Rajput lover suggest the inevitable passage of time as the musical narrative progresses away from Jayadeva's eternal Braj. The knowledge of separate worlds must have been poignantly evocative for those already familiar with the sung verse. The first verse inscribed on the reverse, in Krishna's words (here he is referred to as Madhu's foe), reads:

> "I'll stay here, you go to Radha!
> Appease her with my words and bring her to me!"
> Commanded by Madhu's foe, her friend
> Went to repeat his words to Radha.

The last inscribed verse reads:

> Poet Jayadeva sings
> To describe Krishna's desolation.
> When your heart feels his strong desire,
> Hari will rise to favor you.
> Wildflower-garlanded Krishna
> Suffers in your desertion, friend.[7]

The temporal implications of the two verses have been established in the painting. The artist reminds us that Jayadeva wrote his words to be heard, not just read, that his words enrich the listener, and that the listener has to cultivate the appropriate mood in order to experience a vision of Krishna's springtime passion. The apparently secondary women in this page, the *sakhi* and the singer, are singularly important to achieve all the devotee-con-noisseur's goals.

In the final and twelfth part of the *Gita Govinda,* Jayadeva (and the painter) pulls away from the lovers in union and becomes self-referential (fig. 7). He exalts the soterio-logical or salvational benefits of listening and singing his poem:

> His musical skill, his meditation on Vishnu,
> His vision of reality in the erotic mood,
> His graceful play in these poems
> All show that the master-poet Jayadeva's soul
> Is in perfect tune with Krishna—
> Let blissful men of wisdom purify the world
> By singing his *Gita Govinda.*[8]

In the painting, Jayadeva occupies the same space as a *gopi-sakhi,* but deferentially stands on one leg, savoring his vision of Krishna and Radha. The painter, too, becomes integrated with the poet: they have both helped the viewer achieve Jayadeva's "vision of reality in the erotic mood." Each has performed the task of the *sakhi.*

Bhakti and *Riti*

A circa 1765 page from Kangra or Guler illustrates the first verse of the poet Bihari's *Satasai*, a compilation of individual verses, each of which encodes a discrete narrative (fig. 8):

> Remove my pain of existence Radha, you skillful woman,
> You whose golden complexion turns Krishna green.[9]

The poet and artist begin their endeavor by seeking divine grace. Bihari addresses Radha as a goddess, asking her to take away his earthly existence. He praises her divine and sensuous power over Krishna, and her golden complexion that turns Krishna's blue body green. The word for "green" in Braj *(harit)* is both the color and the state of happiness. The verse enunciates differing attitudes toward sensuality, an ambiguity present throughout the text. Bihari offers homage to Krishna: he stands on one leg as Jayadeva does in figure 7. Yet the setting in which Bihari's devotion is offered is quite different. Although both the *Gita Govinda* and the *Satasai* sets were produced for aristocratic patrons in the same Pahari region, the former is treated as a pastoral in which verdant forests, lush springtime flowers, and flowing waters dominate the landscape, and buildings are irrelevant. The mood of the *Satasai* is different. If Jayadeva praises himself as "the wandering king of bards," Bihari's fame begins in the court.

Under a canopied pavilion, Krishna and Radha sit on a sumptuous jeweled throne, with a parasol highlighting their divinity. Krishna admires a lotus and enjoys its scent as he gazes at Bihari, while his beloved Radha is at his side. Bihari graciously make eye contact only with Krishna, while Radha demurely veils her face. For all their sanctity, they have also become a Rajput king and queen, with a goddess giving *darsan* (ritual gazing) through her *purdah* (veil). The *sakhi*s who in the *Gita Govinda* surround Krishna and Radha in their forest love-play work in this painting as attendants, waving a fly whisk and offering betel leaves. Their equal status as friends of Krishna and Radha has been converted to servility. All signs in the painting indicate a life at court rather than the rustic world of Braj.

The *Satasai* belongs to a genre known as *riti* (style), which emerged in the sixteenth century. *Riti* poets, like many in the Krishna devotional movement, chose to write in the local language of Braj. Modeling their work on earlier Sanskrit texts, they were highly conscious of their aristocratic patronage. Unlike *bhakti* writers who emphasized their sectarian affiliations, *riti* poets consciously styled themselves into literary lineages. Their works encompassed taxonomies of poetic theory, aesthetic sentiments *(rasa),* types of heroes and heroines, as well as inventories of terms arranged by topic on all aspects of culture. Some texts like Keshavadasa's *Rasikapriya* (Connoisseur's delights) begin each section with a definition of the category, followed by illustrative examples. Others, like Bihari's *Satasai*, group short, pithy verses to evoke a mood, describe a hero or heroine, or exemplify a literary category. By and large, *riti* poets favored a combination in which aesthetic, rhetorical, and semantic categories intertwined with love or devotional situations and sentiments.

Scholars of literature have generally separated Braj poetry into two discrete schools, *bhakti* and *riti,* the first sacred and devotional, and the latter courtly, aestheticized, and erotic. The division mirrors the great scholarly embarrassment over *riti* poetry that is part

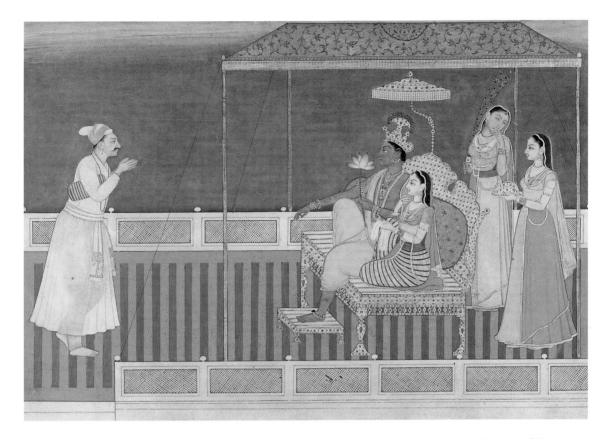

of India's colonial and nationalist heritage. Many critics have scorned *riti*'s emphasis on beauty and eroticism, contrasting it with *bhakti*'s spirituality. Yet, the separation of *riti* and *bhakti* along the line of eroticism versus spirituality simplistically reduces a much more complex dynamic. Formally both genres

Figure 8. *Remove the Pain of My Existence*, from Bihari's *Satasai*, Guler, India, 1760–65. Opaque watercolor and gold on paper, 24.8 x 32.7 cm. Collection of Alvin O. Bellak

use Radha, Krishna, and a *sakhi* as chief protagonists. Both can potentially address a cultivated audience, both use stock phrases and metaphors that can be traced to folk songs and Sanskrit poetry, and both rely on the rhetoric of eroticism to convey emotion. More important, both were reproduced in manuscript form for the same patrons. Perhaps the biggest problem with this division is trying to understand the response of members of the text's initial audience and how they felt about love, Krishna and Radha, the *sakhi*, poetry, and devotion. The stark dismissal of *riti* poetry as indecent is facilitated by simply reading the verses, as against hearing them or viewing them in performance.

Krishna and Radha were treated differently by *riti* and *bhakti* poets. However, it is not the inherent eroticism of one and the supposed lack of eroticism in the other that marks the differential treatment; in the *Gita Govinda* paintings, the artists and audience clearly engage with the poem's explicit sexuality. There are several ways to understand these differences without devaluing *riti*. Court poets who belonged to the *riti* school practiced what I would like to call "*Gita Govinda*fication." Whereas erotic and aesthetic texts like the fifth-century *Kamasutra* (The art of love) posited the cultivated urbanite as their protagonist and audience, *riti* poets entered the space fashioned by Jayadeva to create an extremely fluid body of writing that moves between devotion and urbane eroticism. Writing in Rajput courts, where many patrons and artists were devotees of Krishna, poets

gained access to a vast encyclopedia of culturally valuable symbols by not aligning their work fully with any single mode.

I suggest that *bhakti* and *riti,* when not explicitly equated with devotion versus eroticism, remain useful categories for understanding the audience and the context in which the poetry was performed and painted. A temple viewing of a painting of Krishna and Radha's union would be significantly different from a viewing of the same theme by a king, seated in a court pavilion, for his solitary pleasure. Paintings of *riti* poems like the *Satasai* are valuable interpretations of the texts. They indicate the class structure of the poetry's audience: their size and portability suggest restricted viewings by cultivated kings and by male and female nobility. Each page and its accompanying verses compress conflicting definitions, resulting in two or three possible meanings. Double entendres, alliteration within each verse, and repeated vocabulary allow contradictory sentiments to occupy the same language. A verse can imply explicit eroticism, exalt or mock Radha and Krishna, suggest class conflict, or arouse devotion. Because there is no intrinsic narrative to follow, the *Satasai* has been compiled differently over the years, with only the first verse's placement consistently maintained. The work has an inherent capacity to be shuffled, and its imagery and construction demand a viewer response that differs from the response demanded by the *Gita Govinda.* Yet neither Bihari nor his artist interpreters saw its fluidity as a problem. Artists seem to choose from the verse's various implied meanings and then paint a picture reflecting their chosen interpretation. A *sakhi* becomes critical to this process of making and selecting meaning.

The tasks assigned to *sakhi*s by *riti* poets are based on the *Kamasutra* rather than on Krishna *bhakti* models. Unlike the *gopi-sakhi* of the *Gita Govinda* whose life beyond the bucolic landscape of the poem is never presented, the *riti* go-between's social and professional roles help Krishna and Radha fulfill their desire to be together. Keshavadasa, in his sixteenth-century *Rasikapriya,* a major *riti* text, classifies messengers as

> Nurse, maid, barber woman, an available female neighbor,
> Female gardener, a woman selling betel leaves or bangles, female artist,
> Goldsmith's wife, mixed caste woman, female ascetic, or a silk embroiderer's
> daughter,
> Keshavadasa says for lovers, the *sakhi* makes their destiny.[10]

Here, the *sakhi* is not a *gopi* who gains spiritual and narrative validation by assisting the divine pair but just another inhabitant of the town. Keshavadasa's messengers are all women who, in order to be *sakhi*s, must remain within their economic and social position. *Riti* texts portray a world where romance and male-female interactions are closely monitored; ideal messengers must have legitimate reasons to move from space to space. Doing their work (bangle selling, beautifying, embroidering) becomes vital to the progress of the love affair. The women's subordinate social status positions them as ideal functionaries of elite lovers, allowing them to move between men's and women's spaces without restriction. As Bihari writes, the *sakhi* is not a privileged position from which to worship but a "substructure" on which love affairs are built:

Without the messenger-scaffolding, love is joined by no other means.
Love beams are cemented, messenger-scaffolding is removed, things proceed.[11]

Yet many *riti* authors also question the *sakhi*'s contradictory status as both woman (and thus available and desiring) and neutral go-between. In the world of *riti* poetry, any woman who is openly available to the male gaze is potentially sexualized. In a number of verses, the heroine suspects duplicity in her messenger: did the *sakhi* herself enjoy the hero?

A Painted *Satasai*

A folio from a late-eighteenth-century painted Kangra *Satasai* illustrates this uninscribed verse, a *sakhi*'s description of a peasant guarding her fields (fig. 9):

> A garland adorns her chest, flax flowers her brow,
> Standing up, the girl with upright breasts guards the field.[12]

The artist appreciates Bihari's equation: the riches of the ripening grain fields match the bounty of the girl's body. Her stance is upright and guarded, her breasts blindly gaze back. Because the beauty's head is turned, watching for birds that might steal her grain, the artist can allow the viewer to relish a secret look at her body. Her lushness, youth, and strength contrast with the aged go-between who sits in the balcony with Krishna. Though Bihari never specifies the type of go-between, the artist, aware of *riti* conventions, juxtaposes contrasting female bodies to create a piquant eroticism.

But this painting is not just a comparison of the beauty and her go-between. Krishna with his golden crown and fine jewels is also contrasted with the village girl's simple attire. Although Bihari dismisses peasant life in general, he does incorporate the historical tradition of celebrating Krishna's life in rustic Braj. A medieval commentary on the *Kamasutra,* for example, states that "for a gentleman, relations with peasants are degrading, they are merely substitutes for love. Such forms of sexual release, like neutral sex are only possible if one disguises oneself. Of village girls, the only attractive ones are the cowgirls of Vraja [Braj] country."[13]

The artist skillfully presents the tensions of cross-class, cross-regional love through an erotic fantasy. Interpreting the listening male hero as Krishna allows the cultural symbols associated with his worship to inhabit the same frame as the world of the aristocrat. A contemporaneous viewer could easily see the village beauty as a Braj girl, uninhibited by town mannerisms and available for delectation. The aristocrat as Krishna, or Krishna as aristocrat, is physically separated from her. He is able only to imagine what we know already in the go-between's speech-portrait embodied before us. The improbable relationship between the town building and the field, as well as the choice of go-between, suggests that values other than strict devotion are central to the response sought from the audience. One is humor; Bihari's language is keenly playful. The other is an erotics of power: he knows about her, but does she know of him? He may want her, and given his status how

could she respond with anything but agreement? On the other hand, perhaps the go-between is an emissary for the young girl. On the reverse are several inscribed verses that suggest this reading as well. In one, the beauty says:

> Though they drink till sated, they remain thirsty.
> The thirst of my eyes for the saltlike body of the handsome one is unquenched.[14]

Through his painting, the artist insinuates that a woman's desire can be an equally powerful visual aphrodisiac.

In *Satasai* paintings without Krishna, the *sakhi*'s capacity for desire becomes a powerful tool in the creation of the erotic mood. The beelike *sakhi* of figure 2 cannot see the heroine moving in the moonlight, but she is able to follow her scent. Only a male bee goes after scents, so in this verse and painting the female *sakhi* can also stand in for the desiring male. Simultaneously, the beelike *sakhi* follows the heroine as the heroine follows her own desire. For the viewer, the *sakhi* becomes the point of entry into the narrative. The scene is assembled from her perspective, and, to partake of the pleasure she offers, the viewer must see (inhale) the heroine from the *sakhi*'s angle. Perhaps a desiring beelike *sakhi* also increases the sensuous experience of the male viewer; he is the singular male in the context of the picture and its viewing. In any case, in a single page, the viewer gets two beautiful, questing women.

Some paintings depict the *sakhi* interacting with a second friend who is neither Krishna or Radha. Figure 10 illustrates a series of verses about a love-struck heroine's agitated behavior. On the left, the physically and emotionally agitated heroine *(nayika)* climbs up and down seeking a glimpse of Krishna. Her yo-yo like state is indicated by her piecemeal body, revealed in varying degrees through the openings of the house. In the top window, she is shown bent at the waist, gazing at Krishna below, while in the middle window, she is shown waist down, her face hidden behind the small screened opening. At the very bottom, she is framed in the doorway. Radha, if imagined as a status-conscious Rajput woman from a respectable family, would have led a sequestered life, voluntarily wearing a veil when interacting with most men, including her own family members. Her romantic relationships, if any, would have have been conducted discreetly. To display her desire so publicly, as Radha does in this painting, would have been a matter of shame and family dishonor. The three verses relate the travails of a heroine caught in her love:

> Frenzied, ascending, and descending the balcony, her body is not the least bit tired,
> Caught in the clever one's love, she is like an acrobat's yo-yo.
>
> Restless and distressed, between her new love and her family's shame,
> Pulled both ways, turning and returning, she passes her day like a yo-yo.
>
> From here to there, from there to here, she does not rest for a second.
> Without resting, like a yo-yo, she comes, and she goes.[15]

The building serves as the physical barrier, isolating Radha from her lover. The claims that the frames make on her body mirror the claims of her desires and duties. The two

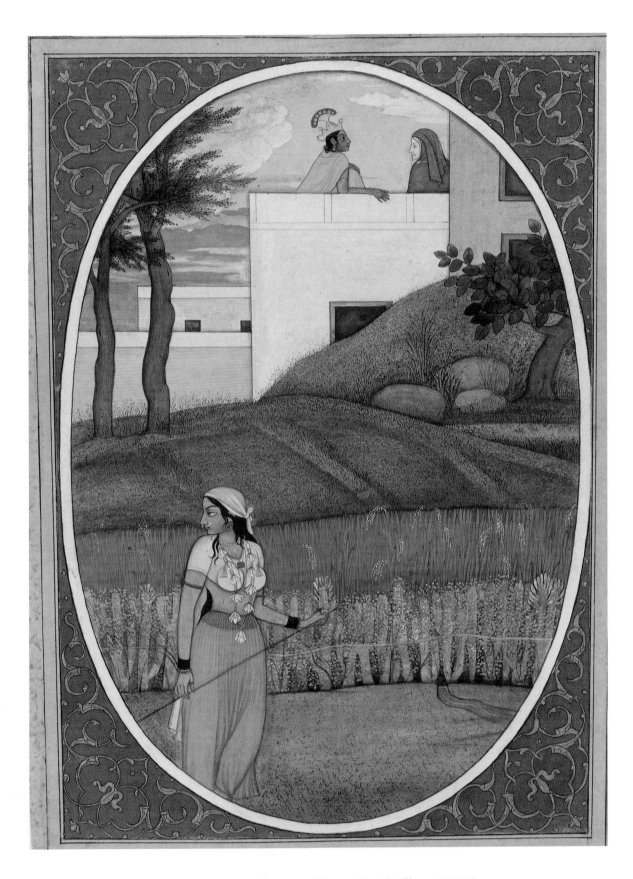

Figure 9. *Village Beauty,* from Bihari's *Satasai,* India, state of Kangra, Punjab Hills, ca. 1780–90.
Opaque watercolor and gold on paper, 20.7 x 14.9 cm. The Kronos Collection

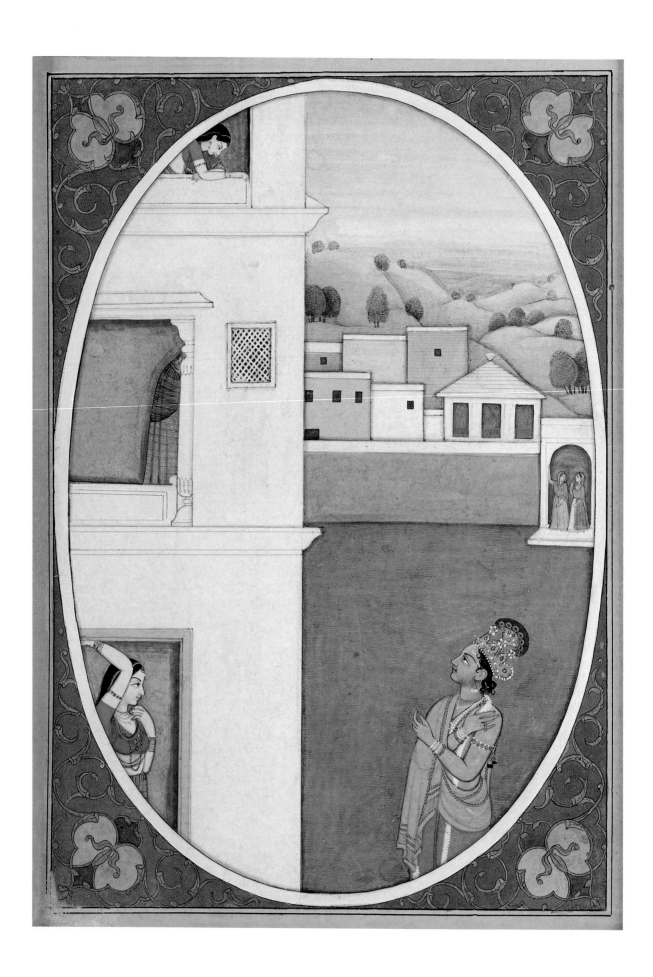

*sakhi*s stand in the distance; one points upward, drawing her companion's attention to the events in the foreground. For the viewer positioned closer to Radha and Krishna, their clandestine exchange of glances is clearly visible. The *sakhi*s deep in the pictorial space emphasize the interiority of Radha's fear of family dishonor, a fear that they voice. Yet the love affair is public; eavesdropping on the conversing women, the viewer can become a voyeur of Radha.

If the *sakhi*s in this painting humorously bare the conflicts endured by Radha, in another painting they celebrate the breach of social norms. Figure 11, inscribed with five verses, clearly plays on the erotic potential of a forbidden love openly displayed in public. One verse is a conversation between two *sakhi*s:

> Speaking, refusing, delighting, angering, meeting, blooming, blushing,
> In a crowded hall, the eyes do all the talking.[16]

Two pairs of *sakhi*s here point to the lovers' transgression and offer it for the viewer's delectation. One *sakhi* in the pair at bottom right points at Radha, while the other holds a hand to her mouth in a gossipy gesture of knowing incredulity. Another *sakhi* in the pair to the left repeats the same gesture. Radha stops at center, her feet moving away from Krishna, her face turned toward him.

Lovers' transgressions and the reactions they produce are grist for the *riti* poet's mill. His *sakhi* is a device to arouse the reader and provide a moralizing presence that throws the social violation into stark relief. Public spaces such as this pavilion offer suitable locations for observers to report on the lovers' deeds. The *sakhi* is the poet's voice, and the scene comes into existence through her. How would viewers know that something happened unless she made it happen?

The *sakhi*s in this painting also demonstrate the ambiguous status of Krishna as object of both erotic and religious devotion. This ambiguity is manifest in the awkward isolation of Radha at the center, in the *sakhi*s' lack of interaction with Krishna, and in the treatment and placement of Krishna's body, which, as if bounded within the frame of a portrait painting, hangs on the wall. In another verse on the back, two *sakhi*s say to each other:

> Facing everyone for a moment, her glance shifts, turning away from all,
> Like a mystic's magic bowl divines the guilty thief, it rests on that side.[17]

The *sakhi*s seem to know that Krishna's figure exists in their space, as the verse establishes ("rests on that side"). The painting plays on a standard *riti* description of the heroine who openly displays love upon seeing her lover's portrait. Because Krishna seems alive only for Radha, the painting implies that, for lovers, the act of representation is double edged. It reminds the lover of the beloved's absence even as it makes the beloved more tangible.

Krishna's beauty is so enchanting that his *gopi*s and his worshipers call him *citcor*, "thief of consciousness." Radha's presence of mind has been stolen. She is unaware of her

Figure 10. *Restlessness of Love,* from Bihari's *Satasai,* India, state of Kangra, Punjab Hills, ca. 1780–90. Opaque watercolor and gold on paper, 19.7 x 14.0 cm. Collection of Cynthia Hazen Polsky

surroundings. Her shifting glance gives her away, just as the divination bowl reveals her thieving lover. But Braj words have complex etymologies and double meanings; the word *kavilanvi,* "magic bowl" or "divination bowl," can also mean a Muslim's compass that the orients the believer toward Mecca at the time of prayer. Thus the same two lines can be translated as:

> Facing everyone for a moment, her glance shifts, turning away from all,
> It rests on that side, like the faithful's compass finds Mecca.

The double meaning of a single word — *kavilanvi* — places Krishna in the space of the religious.

Many North Indian devotional movements enlivened paintings for worship. The final act of inserting the eyes was believed to transform a painted image into a live deity. Once enlivened, the image was regarded by worshipers not just as a representation of Krishna but as Krishna himself. Devotees sought *darshan,* the ritual exchanging of the gaze between devotee and god through this enlivened image. Krishna's *darshan* transmitted his divine grace to his devotee. In turn, the devotee performed for him a series of daily rituals known as *puja* or *seva* (service). These rituals included the morning awakening, bathing, lunchtime feast offering, and live musical entertainment. At night, Krishna paintings and images were covered with curtains so he could sleep. Through such a cycle of rituals, a personal relationship with Krishna was developed and the devotee's life became oriented around him. This ritual process also altered Krishna's status: he ceased to inhabit just the heavens but instead became a welcome and exalted resident of human households.

In this page, Krishna's seating and framing imply his royal and divine status. Like Rajput and Mughal royal portraits, he is presented in partial profile. He is placed in a *jharokha,* or throne-window, where Rajput and Mughal kings sat to give audience. But the *jharokha* also calls to mind the *mihrab* or niche in a mosque wall that indicates the direction of Mecca, and the rolled-up curtain suggests a painting in a home altar or a temple wall. Though none of the verses on the back refer to Krishna as an active participant in the scene, the artist animates him. His head has turned toward Radha; her presence draws his gaze toward her. The hierarchical arrangement, in which Krishna is ensconced in his throne-window and all others are in the pavilion, is subverted as he bends his head in reciprocal desire.

Other verses on the back of the painting indicate Radha's longing for Krishna. In a conversation between her and the *sakhi,* Radha confesses her uncontrollable desire to gaze at Krishna:

> Looking at Krishna's dark body, they have no regard for honor or dishonor,
> What can I do? These flirtatious, desirous eyes go toward him.

In another verse, she tells the *sakhi:*

> I stand filled with his head-to-toe form. Still these eyes ask for a smile,
> They will not abandon their covetous nature.[18]

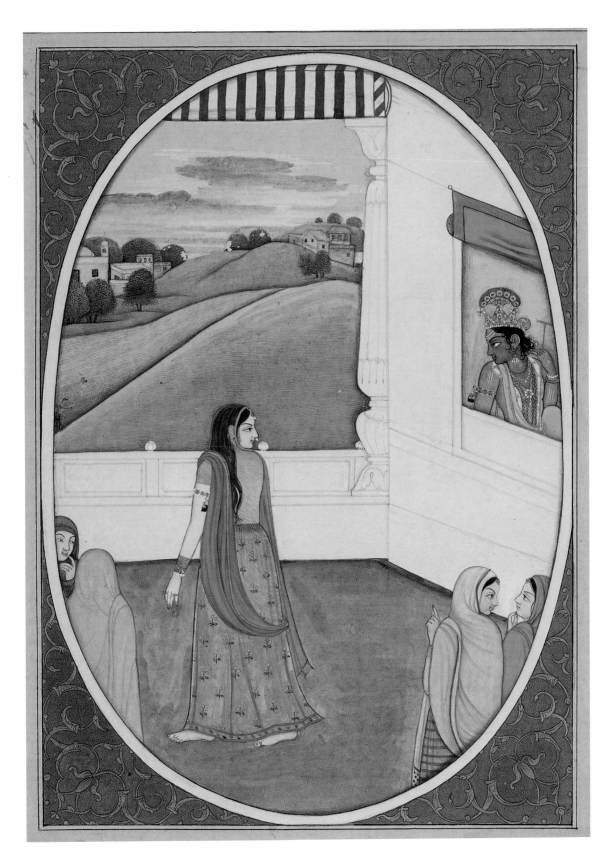

Figure 11. *Meeting of the Eyes,* from Bihari's *Satasai,* India, state of Kangra, Punjab Hills, ca. 1780–90.
Opaque watercolor and gold on paper, 21.3 x 15.2 cm. Collection of Gursharan and Elvira Sidhu

Radha's overpowering yearning undermines one of the standard subjects of *riti* poetry—a woman's physical beauty described from head to toe *(nakh-sikh)* to paint a word-picture for the reader. Here Krishna's body is the object of Radha's ardor. Viewing and interpreting this *Satasai* page as a conversation between the *sakhi* and Radha allows the viewer "unmediated" access to her feelings. She is not only the object of physical admiration but also subject to her own desire. Viewers can identify with the emotions of several figures: Radha's longing for Krishna, Krishna's enjoyment of Radha, or the *sakhis*' general sense of astonishment.

The *Sakhi* as Mediator

This brief exploration of the figure of the *sakhi* in two painted texts suggests avenues for rethinking Rajput love imagery that take into account contemporaneous religious and court cultures which found ways to integrate eroticism, mysticism, aesthetic pleasure, and devotion. The *sakhi* was a crucial intermediary figure in bringing about reconciliations between what today may seem like disparate or irreconcilable positions to occupy in face of the divine.

Like his fellow *riti* poets, Rupa Gosvamin, a sixteenth-century theologian and a leader of the Gaudiya sect devoted to Krishna worship, wrote a commentary on the *Gita Govinda* that represented Krishna as the classic hero and Radha as the archetypal heroine. Rupa wrote that the amorous attitude is best cultivated by the young women of Braj; for them, Krishna is the ultimate lover. He identified these *gopis* as a group of friends led by Radha. Among these *sakhis*, some have greater love for Krishna, some for Radha, while some have equal love for both. Rupa advocated as the devotional ideal the *sakhi*'s unceasing and selfless desire to witness the union of Radha and Krishna. The concept of a *sakhi* assisting the divine couple during their love-play is particularly entrenched in the Gaudiya sect. Its male leaders often envisioned themselves as *sakhis*, performing female gender roles in rituals. Only as *sakhis* did they see themselves gaining access to the amorous path, the apex of religious experience. As David Haberman points out, it is through these paradigmatic *sakhis* that "the entire emotional world of Krishna-lila [love-play] is portrayed and made accessible" to Krishna's human devotees.[19]

Reworking established *rasa* (mood) theories of aesthetics for his *bhakti* theology, Rupa wrote that the erotic mood was essential in achieving the attitude of *shringara*, or "love in devotion." After attaining this mood, worshipers faced two possibilities. They could either imagine direct sexual pleasure with Krishna or vicariously enjoy the emotional experience of any *gopi*, especially of Radha.[20] Rupa privileged the second possibility. Instead of solely seeking self-gratification, the ideal devotee participated in Radha's love affair as a supportive spectator. By refashioning the *sakhi*'s role, Rupa reconciled vicarious, selfless enjoyment with the self-centered pleasure of religious voyeurism. The devotee as friend could altruistically participate in Krishna and Radha's love-play while experiencing a visceral, erotic bliss *(ananda)*. Voyeurism in this devotional context is inextricably linked to *darshan,* the act of ritual gazing that communicates the worshiper's love to the god and

bestows the god's grace on the devotee, as well as to *puja,* a form of worship enacted with enlivened images of the diety. Rupa believed that the *sakhis*' attainment of bliss would inspire others to follow their path of worship.

Rupa's *sakhis* flaunt and operate outside the strictures of ordinary society. They are willing to do anything for the union of the divine couple. Through their assistance, Radha and Krishna overcome shyness, personal quarrels, and social barriers, encountering each other beyond the boundaries of social norms. Rupa's elaborate theology joins selfless devotion to the achievement of *ananda* or bliss. In the process, the devotee's soul is salvaged. Rupa's Gaudiya sect rejected many conventions of religious worship even as it subscribed to others. For Rupa, friendship signified equality, selflessness, and self-gratification. Yet in his theology, viewing Krishna and Radha's illicit love in forest bowers hidden from a disapproving society also bears fruit for their *sakhis.*

By contrast, *riti* poetry is not concerned primarily with creating alternative or emancipatory modes of worship. The poems and paintings locate their emotional and aesthetic power in the social status quo. Public settings are needed for the poems' narrative goals. Though romantic love ostensibly happens between and inside two people, *riti* as a genre is most interested in how it can be brought to the surface and exhibited in society. Although the lovers struggle for privacy and unmediated contact, *riti* poets rarely allow them this insularity. Love remains an aesthetic and social event always in progress; the lovers never ride off into a happily-ever-after sunset. Though she is only a "substructure," the *sakhi* remains in the picture, mediating between the lovers and the reader as a messenger and as an observer. The *sakhi* who comes from the margins of society (barber woman, bangle seller) gains a limited subjectivity by trafficking and policing the love affair. The *sakhi*'s work is the lovers' and reader-viewer's pleasure.

Both *bhakti* and court poets have long mined the love story of Krishna and Radha for literary and pictorial effect. In both religious and courtly settings, there is frank glorification of their beauty and sexuality. Yet my readings of the painted poetry highlight a powerful discourse of eroticism that revolves on the secret display of feelings, on the lovers' covert actions, and on their exposure by *sakhis.* The range of love sentiments expressed and validated seems both distant from and interior to the Rajput courts in which these paintings were made. The solitary male and the ubiquitous female presence suggest that throughout these texts, sentiments of love and romance are best expressed in the company of women. This suggestion is substantiated by another genre of Rajput love painting, one I have not addressed, that depicts male rulers being entertained and gratified in women's quarters. Many such paintings bear inscriptions that identify historical persons; many others remain anonymous. Indian art-historical scholarship is just beginning to address such works in a critical manner.[21]

The historic viewers and the viewing situations of erotic paintings are relatively undocumented. The question of who is allowed to feel what, where, and how is unexplored. The love of gods presented in a devotional setting, the love of gods reproduced for contemplation in the court, and the sexuality of a ruler represented in explicit detail are all different and need to be analyzed as such. Rajputs participated in religious *bhakti* movements like those of Rupa Gosvamin and patronized *riti* poets like Bihari. They also commissioned many other kinds of painting. Images of love and eroticism are one strand in

the fabric of Rajput subjectivity, just as paintings are only one context for the performance of longing and desire.

The artist's and viewer's point of view are primarily located in the *sakhi*'s female body. Simultaneously, the viewer's desire may masculinize a beelike messenger. The fluid embodiment of the artist and the viewer in the paintings throws into question Rajput conceptions of gender. Is there a third sex, a third gender, a third way of looking? Ways of seeing must be historicized by studying gender as a powerful ideology that permeates art, in this case Rajput images of love. Only then can we understand the values and ideologies signified by these paintings of love, sex, and devotion. ❧

Notes

1. Jayadeva, *The Love Song of the Dark Lord: Jayadeva's Gitagovinda,* ed. and trans. Barbara Stoler Miller (New York: Columbia University Press, 1977), p. 118.

2. Bihari, *Satasai,* ed. Sri Jagannath Das "Ratnakar" (Varanasi: Granthkar, 1965), verse 7. All translations of Bihari are mine.

3. The two *Gita Govinda* manuscripts on which I have focused are from the Pahari Hills, produced within seventy-five years of each other and sharing a close textual and artistic relationship. The artists who made these manuscripts have been stylistically and genealogically linked by art historian B. N. Goswamy; many of the pages reproduced here are not only from the same text but are part of the same workshop tradition.

4. Lee Siegel, *Sacred and Profane Dimensions of Love in Indian Traditions as Exemplified in the Gita Govinda of Jayadeva* (New York: Oxford University Press, 1978), p. 135; Jayadeva, *Love Song of the Dark Lord,* trans. Miller, p. 78.

5. Jayadeva, *Love Song of the Dark Lord,* trans. Miller, p. 80.

6. Ibid., p. 90.

7. Ibid., pp. 90, 91.

8. Ibid., p. 125.

9. Bihari, *Satasai,* verse 1.

10. Keshavadasa, *Rasikapriya* (New Delhi: National Museum, 1962), p. 41. The translation is mine.

11. Bihari, *Satasai,* verse 399.

12. Ibid., verse 248.

13. *The Complete Kama Sutra,* ed. and trans. Alain Danielou (Rochester, Vt.: Park Street Press, 1994), p. 205.

14. Bihari, *Satasai,* verse 417.

15. Ibid., verses 44, 50, 51.

16. Ibid., verse 32.

17. Ibid., verse 30.

18. Ibid., verses 157, 158.

19. David L. Haberman, *Acting as a Way of Salvation* (New York: Oxford University Press, 1988), p. 56.

20. In the Gaudiya understanding of Krishna and Radha's love-play, a special *sakhi,* the *manjari,* serves Krishna and Radha's needs during their lovemaking. For the role of the *manjari,* see ibid., p. 108.

21. See Molly Emma Aitken, "Spectatorship and Femininity in Kangra Miniature Painting," in *Representing the Body: Gender Issues in Indian Art,* ed. Vidya Dehejia (New Delhi: Kali for Women, 1997), pp. 82–101.

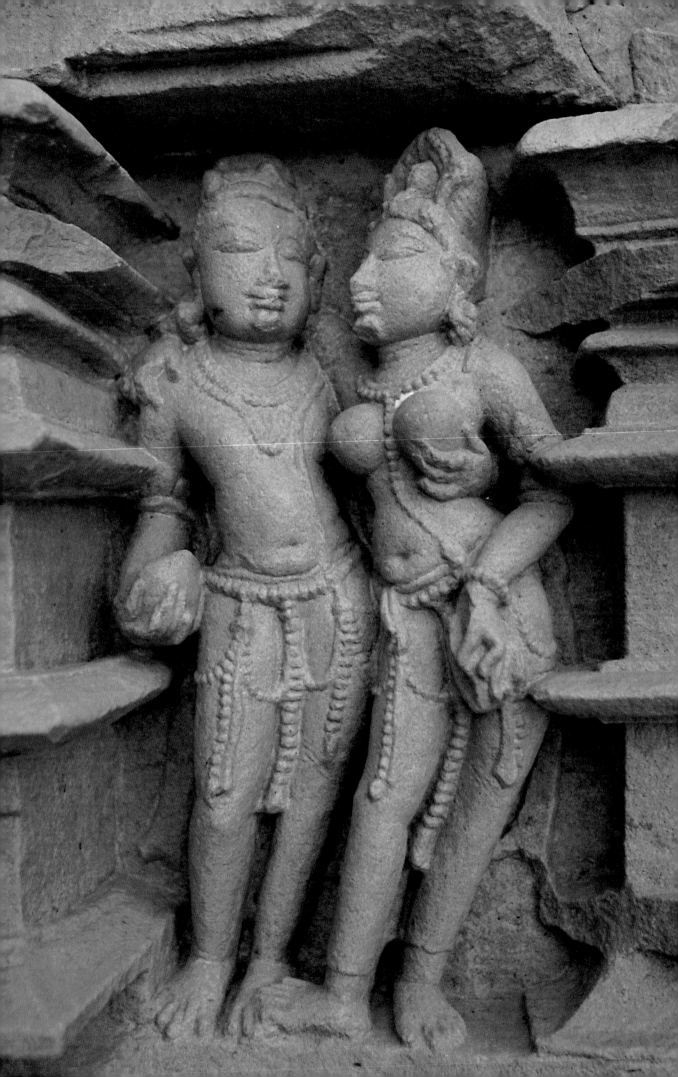

Flushed with love, the moon puts forth his hand
upon the closed breasts of the night whose dark robe he has opened

READING LOVE IMAGERY ON THE INDIAN TEMPLE

Vidya Dehejia

Standing in the midst of scrub forests, with the fragrant blossoms of the *mahua* tree adding crimson splashes of color to the otherwise tan and brown scene, are a group of some twenty-five temples at the site of Khajuraho, ancient capital of the Chandella rulers (ca. 831–1308). Today the sandstone temples are deserted and in partial ruins, but originally they stood in their grandeur along the borders of an ornamental lake of irregular outline. The congregation of so large a number of temples at a single site (the ruins of several more exist), most of them erected within a century and a half, from 950 to 1100, is suggestive of a special goal. The fact that they are dedicated to a range of Hindu deities—Shiva, Vishnu, solar god Surya, and the Goddess—as well as to the saviors of the Jain faith, suggest the possibility that the Chandella monarchs intended their capital to be a major sacred center.

In the last twenty-five years, since tourism has become a priority in India, Khajuraho has acquired fame, one might almost say infamy, as the erotic temple capital of India, and coffee table books highlighting the sensational aspect of this art have proliferated. Khajuraho's entwined figures are carved with remarkable mastery over the flexibility of the human figure, both male and female; they seem to offer a plea to viewers to join the sculptors in their appreciation of the joy of love and sex. But there is much else to admire at Khajuraho, not the least being the exquisite architectural conception of the temples; a series of halls with pyramidal roofs, each taller than the preceding, finally sweep up in a crescendo of curves to the tall tower that crowns the sanctum. Equally exquisite are the sinuously elegant forms of the world of humans and immortals who people the walls of these temples. While the deities are presented frontally and in a somewhat formal mode, the human male and female figures twist and turn with abandon. Figures of both

Detail of embracing couple from the south "joining" wall of the Lakshmana temple

men and women are long-limbed, slender, and sensuous; eyes are elongated, limbs are smooth and pliant; long hair is styled in a great variety of ways; and jewelry is elaborate and abundant. The sculptor's art had clearly reached a stage of great fluency and perfection. Yet we know next to nothing about the sculptors who worked on the temples. All we may assume is that, like elsewhere in ancient and medieval India, a workshop system was in effect and an entire guild worked jointly on each temple to produce its finest work; in such a scenario, individual names were considered somewhat irrelevant.

The joyful experience of love is revealed in distinctive forms of expression found in every culture. Unique to India is the celebration of love in the form of graphic three-dimensional imagery carved in stone on the walls of Hindu temples. Such images were not reserved for the viewing pleasure of a select audience of temple patrons and their immediate coterie; rather, being displayed on the outer walls of temples in a public arena, these erotic images met a much wider gaze. The viewing audience may also have been extremely diverse since temples generally served as a unifying center for different sectarian groups. Irrespective of whether viewer reactions were similar or consistent, the temples continued to function as cohesive institutions that could, and did, encompass a rich variety of attitudes.

Although love imagery was created across the length and breadth of India from the first century B.C. to the nineteenth century, this essay concentrates on the tenth- and eleventh-century temples at Khajuraho in central India, not only because these are renowned for erotic images but also because their sacred iconographic programs have recently been studied. Clearly any assessment of erotic temple imagery must take into account the sacred programs and religious functions of the shrines as well as the cultural milieu.

"Medieval" (ca. 600–1300) India was a culture with attitudes toward sexuality very different from those we encounter today. A consideration of the titles given to a Hindu monarch indicate, for instance, that after heroism, physical distinction was the trait most admired. While the eighth-century Pallava ruler Rajasimha was praised as a great warrior and fearless conqueror, inscriptions on his personal chapel at his capital of Kanchipuram mention also that he was handsome *(abhirama)*, possessed of the grace of the god of love *(kamavilasa)*, and sported the attraction of musk *(gandhahasti)*. When the ruler Vijayalaya established the Chola dynasty (ca. 862–1310) by capturing the southern town of Tanjavur in the year 862, the terminology used in the official declaration alludes to this event as love-sport:

> He, the light of the Solar race, took possession of Tanchapuri—which was picturesque to the sight, was as beautiful as Alaka [mountain], had reached the sky by its high turrets, and the whitewash on whose mansions appeared like the scented cosmetic applied to the body—just as he would seize by the hand his own wife who has beautiful eyes, graceful curls, a cloth covering her body, and the sandal paste as white as lime, in order to sport with her.[1]

When Krishna III of the Rashtrakuta dynasty (ca. 753–973) was crowned king in 939 and prepared to collect revenue from the tax-paying provinces of his Deccan kingdom, the official account described the relationship between the monarch and the provinces, called

quarters, in terms of love-sport. It speaks of "the quarters, which began to tremble and be submissive on account of this preparation to exact tribute—as girls would have manifested tremor and affection at his preparation to take their hand—became pleasing to him in consequence of their observing the proper time for paying it of their own accord—as the others [girls] would have been dear to him in consequence of their keeping to the auspicious juncture for giving themselves away."[2]

Sexuality and love were not treated as private and personal matters; rather, sexuality was a valued attribute of a leader or monarch, to be celebrated in official charters and inscriptions. It is intriguing to note that in ancient Mesopotamia sexuality was similarly linked to potency, male vigor, authority, and hence dominance.[3] In India, it was the hallmark of a ruler that he strike a balance between sexual vitality, which implied regal power, and control of the senses, which spoke of yogic power. It is in this context that the Khajuraho temples and their erotic imagery must be examined.

From the eighth century onward, northern India was divided into series of regional kingdoms of varying size in which local loyalties, rather than a central authority, played a major role. These regional dynastic houses operated on the Indian feudal system in which kings granted land to vassals in return for a portion of the revenue from that land. For the privilege of ruling their mini-kingdoms, feudatories had to provide military support whenever their overlord went to war, to proclaim his name in any inscriptions they issued, and to attend his court on a variety of ceremonial and formal occasions.

In the early tenth century, local Chandella chieftains with somewhat dubious tribal backgrounds had, for a period of a hundred years, ruled a small area of northern India as feudatories of the powerful Pratihara dynasty whose kingdom lay to their north and east. In a bold move, Yashovarman Chandella (reigned 925–50) appropriated from his Pratihara overlord an important statue of Vishnu and built a sandstone temple to enshrine it at his capital of Khajuraho. This temple, known today as the Lakshmana, and completed by his son Dhanga in 954, was Yashovarman's defiant gesture to establish the sovereignty of his new dynasty. The early part of Dhanga's reign was devoted to extensive military activity to consolidate the new kingdom. His own temple known as the Vishvanatha, completed in 999, was dedicated to Shiva and enshrined both a stone and an emerald linga. Since the use of emerald in images of worship traditionally signifies the fulfillment of desires, the consecration of the emerald linga may have been Dhanga's act of thanksgiving both for his military successes and for his lifespan of close to a century. One of the most important of Chandella rulers was Vidyadhara (reigned 1004–35), during whose reign the Chandellas were recognized as the dominant power in northern India; Vidyadhara twice organized successful resistance against the early Muslim invaders of India. It is probable that he was the builder of the Kandariya Mahadeo temple that marks the climax of building activity at Khajuraho.

Hindu temples, simple in plan, consist of a square sanctum fronted by a square hall; larger temples may have a second hall as well as a porch. Among the twenty or so still standing at Khajuraho are three large *sandhara* temples in which an inner circumambulatory passage encircles the shrine; these three temples are the focus of this essay. The earliest of these *sandhara* temples is the Lakshmana, the creation of the first Chandella ruler Yashovarman, completed in 954 and dedicated to Vishnu. It was followed by two Shiva

temples, the Vishvanatha temple of King Dhanga, completed in 999, and the Kandariya Mahadeo temple created almost certainly by King Vidyadhara (fig. 1). All three temples display a graceful grouping of the superstructures of their four units, with the lowest pyramidal roof over the entrance porch and the successively taller pyramids above the two halls, sweeping up to the elegant tower above the shrine. All three exhibit prominently placed erotic imagery and are royal commissions of the Chandella monarchs.

Ancient *shilpa*, or art, texts written for practicing architects and sculptors, speak of the sanctum as the bridegroom and the main hall as the bride and refer to the juncture wall between them as the *milana-sthala*, or meeting-place. The texts further specify, "That place in front where the bridegroom meets the bride becomes the *sandhiksetra*, or place of juncture" (also trysting place).[4] It is on the exterior of these juncture walls of the Lakshmana, Vishvanatha, and Kandariya Mahadeo temples that we find the erotic imagery for which Khajuraho is renowned. The ground plan of the *sandhara* temples (and only of these) reveals that the square of the sanctum and the square of the hall actually overlap to create this juncture wall. The occasional small erotic figure appears on various parts of the temple; however, it is at the very center of this joining wall, this meeting-place, that the temple builders carved a panel of entwined or "joining" couples, positioned on two or three levels according to the scale of the temple (figs. 2, 3).

The idea of thus creating a visual and architectural pun need not seem strange or far-fetched since it was a commonplace in the literary vocabulary. For instance, the lengthy dedicatory inscription on the Vishvanatha temple contains a passage that plays with the dual meanings of the word *digambara*, meaning "sky-clad," a word largely used to designate the Jain sect of naked monks. One verse of the inscription is in the form of a joking dialogue between god Shiva and his consort Parvati; she inquires

Figure 1. The Kandariya Mahadeo temple at Khajuraho, dedicated to god Shiva and built during the reign of Chandella monarch Vidyadhara (1004–35)

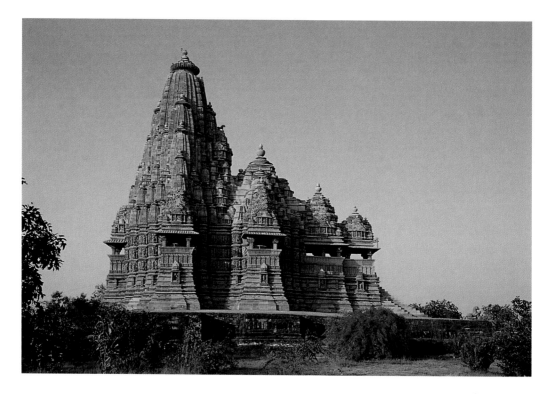

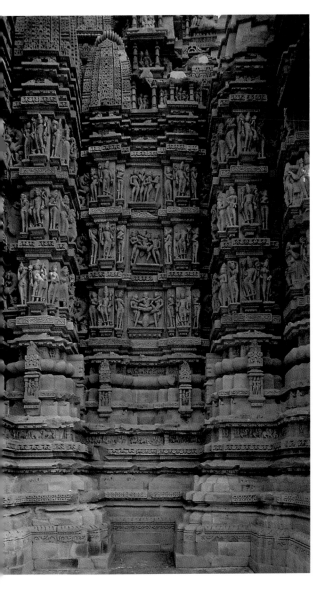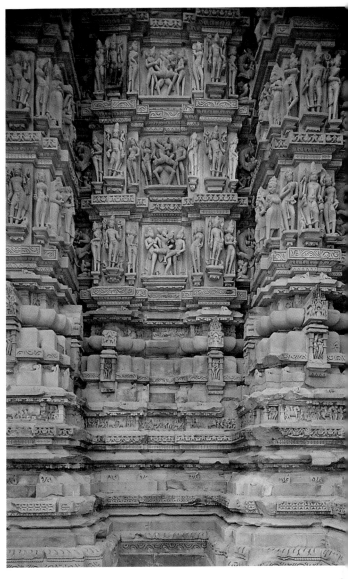

who is at the door and intentionally pretends to misunderstand Shiva when he answers "Digambara" (Shiva often went around clad only in a loincloth with snakes and other ornaments to cover him). Parvati counters that she will not open the door to a Jain monk.[5] With puns a common form of literary expression, it should be no great surprise to come across puns in the visual arts and to find images of *sandhi* (union) at points of *sandhi* (juncture or combination).

Figures 2 and 3. The south and north "joining" wall, connecting the shrine and hall of the Kandariya Mahadeo temple and adorned with sculpted images of "joining" couples

Imagery as Auspicious and Celebratory

In exploring the erotic imagery, the obvious is often overlooked: one reason for the profusion of such imagery on temple walls is surely to celebrate the joy and pleasure of life, of love and of sex. This important fact is often relegated to oblivion in the desire to seek explanations for what has today become an embarrassment to many Indians, whose earlier

Figure 4. *Mithunas* (loving couples) in the veranda of the Buddhist rock-cut chapel at Karle, 1st century A.D.

heritage has been superseded by centuries of Islamic thought, British Victorian values, and nationalistic ideals. The loving couple, or *mithuna*, is a stock theme of Indian art, being seen as early as the first century B.C. in the decoration of Buddhist stupas. The significance of the theme is demonstrated by the prominence given to *mithunas* in the veranda of the rock-cut Buddhist monastic chapel at Karle, created in the first century A.D. along the west coast of India, where we find eight life-sized loving couples with sensuously modeled bodies (fig. 4). Each male fondly places his arm around the shoulder of his partner, and inscriptions, speaking of them as *mithunas*, inform us that some were gifted by monks. For voluptuous couples to be thus displayed in a sacred Buddhist monastic setting at Karle, the *mithuna* theme must have won early widespread acceptance. The couple, like the individual woman, was an obvious and indisputable emblem of fertility, and thereby of growth, abundance, and prosperity. From this, it was a short step to considering the couple an auspicious emblem, equally appropriate for adorning the walls of a palace, a temple, or a Buddhist chapel. When sculptors of the third century A.D. created friezes portraying the main events from the Buddha's life as decoration for monuments at the Buddhist monasteries of Nagarjunkonda, they considered it wholly appropriate to separate each life scene with loving couples flanked by pilasters.

To state that love was a prominent theme in art, whether sacred or secular, might seem curious to those less familiar with the tenor of life in ancient India. Ancient Indian sages propounded that the goals of life were fourfold, and each individual was exhorted to

pursue all four and not neglect any in favor of the other three. *Dharma* implied ethical living; *artha* was the acquisition of wealth through the rightful pursuit of one's profession; *kama* was love (familial and sexual); and *moksha* was spiritual liberation. While a Hindu temple was constructed to aid the pursuit of spiritual liberation through meditation, symbolized by the worship of the deity enshrined within its sanctum, it was appropriate that the temple reveal the wholeness and totality of life by carrying on its walls imagery relating to the other three goals. In addition to portraying stories from the myths relating to the deities, the temple walls frequently show preaching sages, scenes of hunting, festival processions, as well as images of women, couples, and lovemaking. It is in this context that one may seek to understand much of the love imagery on temple walls.

Equally significant is the auspicious-cum-apotropaic role played by images of couples in protecting a temple. Cultures across the world—for instance Pompeii during the second and first centuries B.C.—have believed in the power of images, particularly of those that depict inappropriate attitudes, sexual or otherwise.[6] Warding off the evil eye by the use of apotropaism is not a rare phenomenon. Places of juncture, in particular, are considered to be especially vulnerable points, liminal areas that require additional protection. And it is precisely where the sanctum of the Khajuraho temples meets the hall that such apotropaic images are seen in greatest profusion. In fact, as one examines the temples more closely, one may discern erotic figures placed along the juncture of the roofs as well.

Metaphor

Images of loving couples may also be understood on a metaphorical level. Several decades ago the eloquent writer Mulk Raj Anand coined the phrase "union of cosmic principles" to suggest that entwined couples represent the union of the individual human soul with the divine (fig. 5). Ancient philosophical texts known as Upanishads, composed beginning in the fourth century B.C., put forward a philosophy termed "monism" that opposed any kind of dualism and proposed that the individual soul and the universal soul were not two distinct entities. Rather, the individual soul emerged from the universal principle, lived its life on earth, and when it reached an advanced spiritual state, it merged back into the universal soul, realizing the bliss of salvation. To explain this profound philosophy of the essential unity of an apparent duality, the sages of the Upanishads used sexual terminology. They compared the bliss of salvation that arises when the individual soul merges with the universal soul to the blissful state that arises when lovers merge and lose themselves in each other. If sexual terminology could be used freely and explicitly in sacred literature to explain the concept of monism and the bliss of salvation, then surely it could be used in the visual arts, as three-dimensional sculpture, to explain the same concept.

Can the metaphorical explanation be extended to the scenes on the juncture walls of the three *sandhara* temples at Khajuraho? These joining scenes invariably portray an erotic couple flanked by two other figures, one male and one female, though occasionally both female, who actively assist the couple in achieving their union. For instance, both the Kandariya Mahadeo and Vishvanatha temples feature a couple united in a yogic-coital

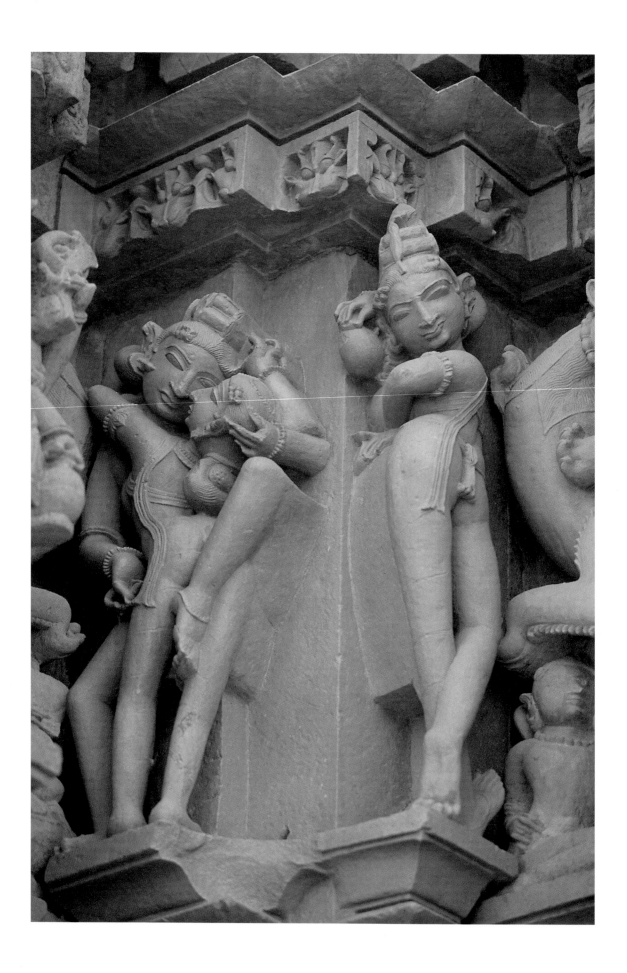

posture with one partner in the headstand pose and the other supported by helpers. Is it too radical to suggest that spiritual union needs the intervention of gurus and guides to lead to that state of liberation? When the Vishvanatha wall depicts unconventional postures, is it going too far to say that they, too, may be interpreted on a metaphorical level? It may be difficult for us to conceive of such a concept since, as twentieth-century viewers, we are accustomed to regarding sex as an intimate private matter.

What about the viewers and their responses to the erotic imagery on the temple walls? In India's ancient theory of aesthetics, a viewer response theory called *rasa-shringara*, or love, is the first of the nine aesthetic emotions, or *rasas*; in fact, love is described as the king of *rasas (rasaraja)*. To what extent can we suggest that a response of arousal may have been intended to resonate with

Figure 5. Left: Intertwined couple on wall of the Devi Jagadamba temple at Khajuraho, 11th century

Figures 6 and 7. Below: The south and north "joining" walls, connecting the shrine and hall of the Vishvanatha temple, adorned with sculpted images of "joining" couples. This Shiva temple was sponsored by Chandella ruler Dhanga and completed in the year 999.

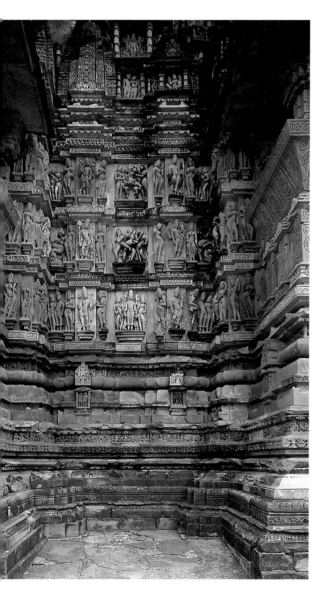

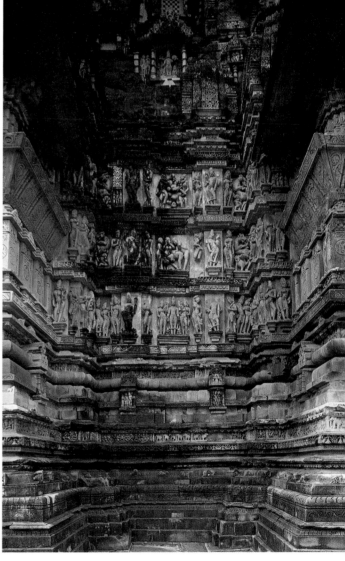

the importance given to fertility? A point that needs consideration here is the bashful attitude of the "helpers" in two of the scenes on the Vishvanatha temple's joining walls; in one, both women flanking a coital couple cover their faces with one hand in apparent embarrassment, while in another, a woman uses both hands to cover her eyes (figs. 6, 7). On the Lakshmana temple, the woman next to an entwined couple turns away from them with a degree of hesitance and uncertainty. On the Kandariya Mahadeo walls, by contrast, none of the figures display any misgivings but appear quite matter-of-fact regarding the activities of the central couple. It would seem that the temples embody the two apparently contradictory attitudes of acceptance and embarrassment toward sexuality. Such images do not seem to be metaphors for spiritual bliss; if they were thus intended, surely flanking figures would not display misgivings but would rather reinforce the underlying metaphor.

Esoteric Tantric Sects

One explanation of the activities portrayed on these juncture walls is that they represent the practices of esoteric tantric sects. The Kaula sect of Shaivism, for instance, which was prominent during the tenth and eleventh centuries when the Khajuraho temples were built, believed that the path to salvation lay through the five Ms, so-called because each of the five items start with the Sanskrit letter *M*. These five ingredients are *matsya*, or fish; *mamsa*, or meat; *mudra*, or grain; *mada*, or wine; and *maithuna*, or sex. Kaulas defined the ultimate state, to which they gave the name Kula, as one in which sight and mind are united, the sense organs lose their individuality, and sight merges into the object to be visualized.[7] They advocated the path of *bhoga*, or enjoyment, rather than yoga, or discipline. Contemporaneous literature speaks disparagingly of their lavish banquets that culminated in orgiastic rituals. While the sculptures have indeed been read as portraying the rites of such tantric sects, the explanation presents problems that need to be resolved. Since all three temples are royal dedications, the implication would be that the monarchs themselves were followers of tantric practices; inscriptions, however, suggest that the monarchs followed the Vedic path. The Lakshmana temple inscription, for instance, concludes with the wish "May the law of the three Vedas prosper!" The Vishvanatha temple record speaks of religious services administered according to the *Shastras*, or orthodox sacred texts, by chief priest Yashodhara, and performed by Brahmans of pure lineage. A second problem pertains to the secret hidden nature of tantric practices that, according to their texts, must never be divulged or revealed to a non-initiate. Why then would their practices be displayed so prominently on temple walls? The only way to counter this objection would be to postulate that portrayals of Kaula tantric practices were permitted by their Vedic opponents in order to hold them up to public ridicule. This explanation is, however, exceedingly unlikely, for ridicule hardly thrives via emphatic portrayal of the ridiculed on the walls of such magnificent temples. Similarly suspect is the suggestion that the naked figures of "monks" seen in certain panels represent monks of the *digambara* sect of heterodox Jains who are thus held up to public contempt.[8] This issue is unresolved.

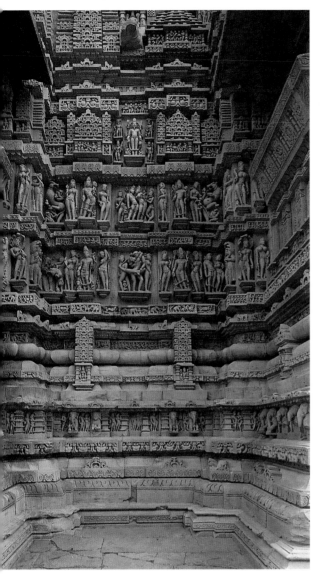
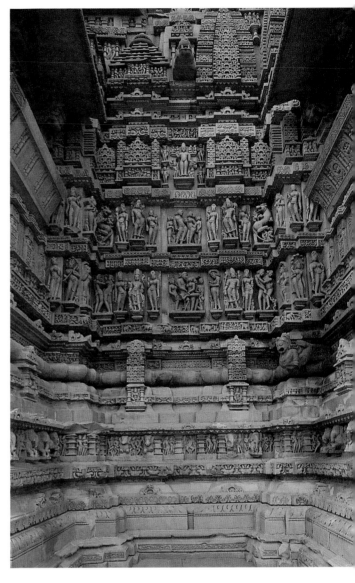

It should be noted that tantra visualizes a set of seven *chakra*s, or centers of spiritual energy, that exist at various points within the body. The lowest is visualized at the base of the spine, the next in the genitalia, and the topmost at the apex of the skull. Tantric practitioners strive to arouse awareness within the *chakra*s, directing sexual energy upward toward the top of the skull. When such energy reaches the topmost *chakra*, known as *sahasrara*, or thousand-petaled lotus, a state of meditative bliss is achieved. Throughout such tantric practice, arousal is to be maintained to achieve a state of meditative perception; seed is never to be spilled. It is this aspect of ascetic and yogic arousal that is behind the concept of the linga of Shiva; the phallic emblem represents Shiva's yogic and meditative control and not his sexuality, as might mistakenly be thought.

Figures 8 and 9. The south and north "joining" walls, connecting the shrine and hall of the Lakshmana temple, adorned with sculpted images of "joining" couples. This temple, dedicated to god Vishnu, was constructed by Yashovarman Chandella and dedicated by his son Dhanga in 954.

Allegorical Play

Among the most intriguing and ingenious attempts to explain the Khajuraho images is the suggestion that the erotic panels arranged in two levels on the Lakshmana temple represent the characters of an allegorical play.[9] On both juncture walls of the Lakshmana, the upper erotic group is a dignified standing *mithuna* couple while, by contrast, the lower couple is entwined and accompanied by a "monk"-like figure (figs. 8, 9). Allegorical plays were a known feature of the Indian literary scene, and one such, the *Prabodhacandrodaya*, or "Moonrise of Awakening," was written for the Chandella monarch Kirtivarman, who ruled an entire century after the construction of the Lakshmana temple. This later play presents the battle between the camps of two rival monarchs. On the one side is King Viveka or Discrimination (a term used to indicate the power to discriminate between right and wrong, real and illusory), his wife Upanishad (a Vedic philosophic text), their son Awakening, and their allies such as Reason, Faith, and Peace. In the opposite camp is King Mahamoha, or Delusion, his paramour Mithyadrishti (Error), and their allies, the Kapalikas (an extreme Shaiva cult), the Carvaka materialists, the Buddhists, the Jains, as well as Deceit, Greed, and Egoism. On the allegorical level the play may be viewed as the defeat of delusion by discernment, resulting in the rise of awakening and knowledge. It may also be seen in the framework of battle between the Vedic order and various heretical sects. And finally, as the play's prologue suggests, it represents the combat between the Chandella King Kirtivarman, who is likened to Discrimination, and his rival, the Chedi monarch, likened to Delusion. For the dignified *mithuna* on the upper level of the Lakshmana temple's joining wall to be read as King Viveka and Queen Upanishad, and for the lower entwined couple to be seen as Mahamoha and his paramour, it would first be necessary to postulate the existence of an earlier version of the play in the reign of King Yashovarman, patron of the Lakshmana temple. It would also be necessary to suggest a reason such a play held so special a significance for the monarch that he thought it worthy of depiction on the walls of his temple. The attempt to identify specific characters from the play in the many flanking figures seen on the Lakshmana walls seems somewhat forced. There is no known precedent for such a representation. Finally, even if such an explanation is proposed for the Lakshmana temple, it cannot apply to the other two *sandhara* temples. Of the three tiers on the Vishvanatha temple's joining wall, the lowest portrays a deity while the upper two tiers both show active erotic scenes and not contrasting groups. In the Kandariya Mahadeo temple, all three tiers depict intense erotic poses. The gestures of the figures sculpted on the temple walls are indeed dramatic, serving to remind us that dance and drama played an important role in shaping the repertoire of visual artists in ancient India. Artistic vocabulary drew heavily upon dramatic vocabulary, and the Khajuraho temple walls strongly suggest a public display and viewers; they seem to be concerned with communicating with an audience rather than with encoding esoteric ideas (fig. 10).

Even within the field of erotic images, the Khajuraho temples carry a hierarchy of representation. Upon the juncture walls of the temples themselves are aristocratic and divine figures; along the platform upon which each of the temples stand are a range of figures of lesser status variously engaged, but including also baser forms of eroticism such as bestiality. These depictions seem to defy explanation.

Figure 10. Villagers performing *puja* at Khajuraho

Sacred Program

It would be appropriate now to turn to the sacred programs of the temples, of which the Lakshmana is dedicated to Vishnu, and the Vishvanatha and Kandariya Mahadeo to Shiva. Recent scholarly research on the iconographical programs of these temples indicates that their imagery is based on the concept of a hierarchical and pyramidal emanation of deities or cosmic elements.[10] Starting from the inner sanctum and moving outward, such emanation results in the evolution of the universe; in reverse, commencing from the exterior and moving inward, the emanation culminates in its involution or dissolution.

The philosophic system known as Pancharatra is seen as the basis for the Lakshmana Vishnu temple. Pancharatra visualizes the unmanifest supreme without form, who then enters the stage of being-becoming and finally manifests in a variety of forms that include the incarnations of Vishnu. In meditative practice, the devotee starts with the manifest and moves gradually toward the supreme being. The existence of such a complex metaphysical ideology makes it problematic to sustain the theory that an allegorical play was portrayed on the temple's walls. The ideology underlying the Shiva temple of Kandariya Mahadeo is

Figure 11. Priest beside the colossal linga or aniconic form of Shiva, of polished sandstone and more than two and one-half meters tall, from the Matangeshvara temple, 11th century

Figure 12. Far right: Detail of embracing couple from the south "joining" wall of the Lakshmana temple

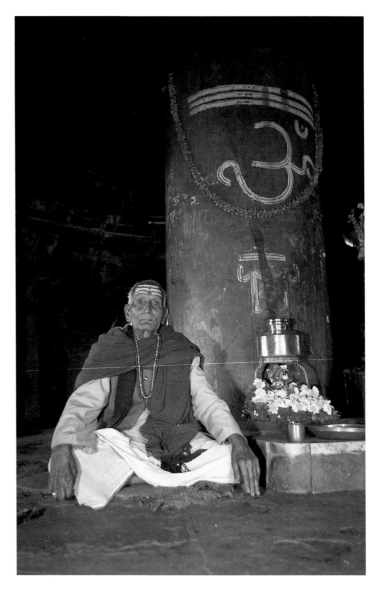

the Shaiva Siddhanta system; its emanation principle commences with formless Shiva in the sanctum's aniconic linga (fig. 11) and moves through the manifest-unmanifest Sadashiva, to the various manifest forms of Shiva.

Both the Vaishnava Pancharatra system and the Shaiva Siddhanta philosophy assert that the supreme being, who is unmanifest and formless, takes on form to help the devotee in worship and meditation. Both are esoteric paths that belong to the right-handed *(dakshina)* tantra as opposed to the left-handed *(vama)*. The distinction between right- and left-handed tantra lies in the concepts of literality and symbolic substitution; thus if a tantric text demands an offering of blood, left-handed tantrics follow it literally while the right-handed system would substitute a blood-red hibiscus flower. So, although the inscriptions of the monarchs responsible for these temples speak of them as upholding the Vedic path, they appear, in fact, to be followers of right-handed tantric philosophies that were apparently not considered to be heterodox paths but accepted as belonging within the scope of the Vedic fold.

Returning to a reading of the love imagery on these temple walls, we find ourselves

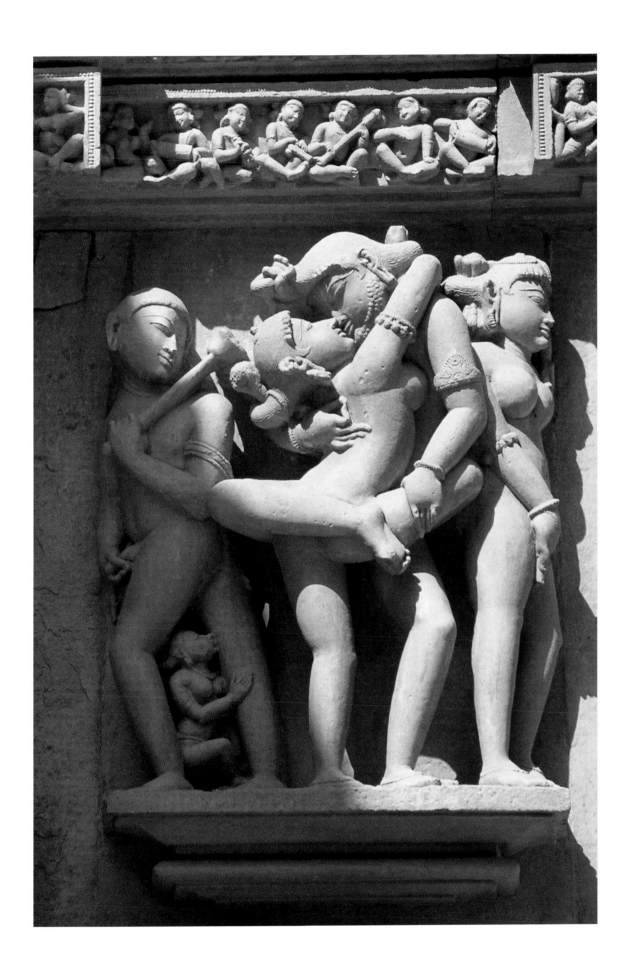

faced with a curious situation. Since all three temples belong to philosophical systems of right-handed tantra, and since such systems, whether Shaiva or Vaishnava, believe in substitution, one might ask why the temple walls portray actual sexual rites in place of using a substitute for the element of *maithuna,* or sex. Perhaps the answer is implicit in the very question. Perhaps the stone imagery on the temple walls stood as a substitute for the physical performance of sexual rites (fig. 12). Possibly this last hypothesis is one that most adequately takes into account the various apparently conflicting facts and provides a manner of coming to terms with the erotic imagery and a means to partially reconcile apparent contradictions.

Love Imagery

One thing is certain: no single explanation accounts for the many categories of love images on the temple walls, which may be read on a number of levels, depending perhaps on the level of cultural and spiritual sophistication of the viewer. *Mithuna*s, or loving couples, stood for growth, abundance, and prosperity and were an auspicious and accepted decoration on temple walls; they made reference also to *kama,* one of the four goals of life in ancient India. Erotically entwined "joining" images were placed on the walls that connect the sanctum likened to the bridegroom, with the hall likened to the bride, to create a visual and architectural pun. Love imagery also served an auspicious-cum-apotropaic function, placed specially at those vulnerable points where a juncture occurred in order to protect a temple from danger. Love images may also be read on a metaphorical level, with the bliss of sexual union understood to suggest the bliss of salvation that arises upon the union of individual soul with the infinite. Finally, we must take into account the fact that the sacred programs of the temples belong to right-handed tantric paths that reject the extreme and literal practices of left-handed tantrics and use symbolic substitution for various rites including the five *M*s. The sculpted love imagery on the joining walls of the temples may be interpreted as the substitute for the physical performance of sexual rituals by the right-handed tantrics, whether followers of the Pancharatra or Shaiva Siddhanta systems. ☁

Notes

The epigraph is from "The Moon," *Sanskrit Poetry from Vidyakara's Treasury,* trans. Daniel H. H. Ingalls (Cambridge, Mass., and London: Belknap Press of Harvard University Press, 1979), no. 944, p. 205.

1. Inscription no. 205, verse 45, in *South Indian Inscriptions* (Madras: Archaeological Survey of India, 1920), 3:418.

2. Quoted in R. G. Bhandarkar, "Karhad Plates of Krishna III: Saka-Samvat 793," *Epigrahia Indica* 4 (1896–97): 278–90.

3. Irene J. Winter, "Sex, Rhetoric, and the Public Monument: The Alluring Body of Naram-Sin of Agade," in *Sexuality in Ancient Art,* ed. Natalie Boymel Kampen (Cambridge: Cambridge University Press, 1996), pp. 11–26.

4. Ramacandra Kaulacara, *Silpa Prakasa,* trans. Alice Boner and Adasiva Rath Sarma (Leiden: Brill, 1966), pt. 2, p. 111.

5. Devangana Desai, *The Religious Imagery of Khajuraho* (Mumbai: Franco-Indian Research, 1996), pp. 177–78.

6. John Clarke, "Hypersexual Black Men in Augustan Baths: Ideal Somotyes and Apotropaic Magic," in *Sexuality in Ancient Art,* ed. Kampen, pp. 184–98.

7. Pramod Chandra, "The Kaula-Kapalika Cults at Khajuraho," *Lalit Kala* 1, no. 2 (1955–56): 98–107.

8. Desai, *Religious Imagery of Khajuraho,* p. 181.

9. Ibid., pp. 181–89.

10. Ibid.

Revealing the Romance in Chinese Art

Bickford, Maggie. *Ink Plum: The Making of a Chinese Scholar-Painting Genre.* Cambridge, England: Cambridge University Press, 1996. Insightful discussion of plum flower imagery and women.

Clunas, Craig. "The West Chamber: A Literary Theme in Chinese Porcelain Decoration." *Transactions of the Oriental Ceramic Society* 46 (1981–82): 69–86. Studies some aspects of *The Story of the Western Wing* as a motif for commercial art commodities.

Delbanco, Dawn Ho. "The Romance of the Western Chamber: Min Qiji's Album in Cologne." *Orientations* 14, no. 6 (June 1983): 12–23. Study of a famous late Ming album.

Fu Xihua. *Zhongguo gudian wenxue banhua xuanji.* Shanghai: Renmin meishu chubanshe, 1981. Vols. 1, 2. Contains woodblock print illustrations of *The Story of the Western Wing.*

Hay, John. "The Body Invisible in Chinese Art?" In *Body, Subject and Power in China,* edited by Angela Zito and Tani E. Barlow, pp. 42–77. Chicago: University of Chicago Press, 1994. Discusses the cultural construction of nudity and sexuality in China.

Laing, Ellen Johnston. "Chinese Palace-Style Poetry and the Depiction of *A Palace Beauty.*" *Art Bulletin* 72, no. 2 (June 1990): 284–95. Laing, "Erotic Themes and Romantic Heroines Depicted by Ch'iu Ying." *Archives of Asian Art* 49 (1996): 68–91. Invaluable studies of images of "beauties" in Chinese art and the intertwining of this subject, especially in Ming dynasty painting, with images of love and eroticism.

Li Wai-yee. *Enchantment and Disenchantment: Love and Illusion in Chinese Literature.* Princeton, N.J.: Princeton University Press, 1993. Thoughtful discussion of love in the literary tradition.

Wang Shifu. *The Story of the Western Wing* (Xixiang ji). Edited and translated and with an introduction by Stephen H. West and Wilt L. Idema. Berkeley: University of California Press, 1995. Outstanding translation, annotation, and historical introduction to the play.

Wang Yao-t'ing. "Images of the Heart: Chinese Paintings on a Theme of Love." Translated by Deborah A. Sommer. *National Palace Museum Bulletin* 22, no. 5 (November/December 1987): 1–21, and no. 6 (January/February 1988): 1–21. Pioneering article that identifies some popular love stories depicted in painting.

Wu Hung. *The Double Screen: Medium and Representation in Chinese Painting.* Chicago: University of Chicago Press, 1996. Comprehensive review of *The Night Entertainment of Han Xizai* and provocative ideas about Qing dynasty court paintings of women.

Picturing Love Among the *One Hundred Poets*

Hirshfield, Jane, with Mariko Aratani, trans. *The Ink Dark Moon: Love Poems by Ono no Komachi and Izumi Shikibu, Women of the Ancient Court of Japan.* New York: Charles Scribner's Sons, 1988. Good translations of two major poets of the Heian era.

Leupp, Gary P. *Male Colors: The Construction of Homosexuality in Tokugawa Japan.* Berkeley: University of California Press, 1995. A deeply flawed book, but the only substantial introduction in English to homoerotic practice in pre- and early modern Japan.

Link, Howard A., with the assistance of Jūzō Suzuki and Roger S. Keyes. *Primitive Ukiyo-e from the James A. Michener Collection in the Honolulu Academy of Arts.* Honolulu: University of Hawaii Press, 1980. Still the best book on early ukiyo-e artists such as Hishikawa Moronobu; includes plates of the *Fūryū sugata-e hyakunin isshu.*

Mostow, Joshua S. *Pictures of the Heart: The Hyakunin Isshu in Word and Image.* Honolulu: University of Hawaii Press, 1996. A complete translation of the *One Hundred Poets* collection, including a discussion of the differing interpretations and illustrations of each poem found in premodern and early modern commentaries.

Ihara Saikaku. *The Great Mirror of Male Love.* Translated by Paul Gordon Schalow. Stanford, Calif.: Stanford University Press, 1990. A complete translation of Ihara Saikaku's major work of homoerotic fiction with a fine introduction that situates the stories within both Saikaku's complete oeuvre and Tokugawa culture.

Tahara, Midred, trans. *Tales of Yamato.* Honolulu: University of Hawaii Press, 1980. A complete translation of this collection of poetic anecdotes from the late-ninth–early-tenth-century Heian court.

Yasumura, Toshinobu, ed. *Tan'yū, Morikage, Itchō*. Vol. 4 of *Edo meisaku gajō zenshū* (Masterpieces of painted albums from the Edo period). Tokyo: Shinshindō, 1994. In Japanese, with English summary and captions. Includes color reproductions of Kano Tan'yū's *Shin sanjūrokkasen* album and Kano Tsunenobu's *Waka jittei*.

Japanese Love Poems

Miller, Stephen D., ed. *Partings at Dawn: An Anthology of Japanese Gay Literature*. San Francisco: Gay Sunshine Press, 1996. The largest assemblage of its kind and something not yet attempted in the original country, Japan. Modern and premodern poetry are included as well as Paul Gordon Schalow's translation of Kitamura Kigin's *Wild Azaleas* and a general introduction by Schalow; Takahashi Mutsuo's thousand-line *Ode;* and a larger selection of Ishii Tatsuhiko's tanka.

Sato, Hiroaki, trans. *Breeze Through Bamboo: Kanshi of Ema Saikō*. New York: Columbia University Press, 1997. The first book devoted to a woman's *kanshi*, illustrated by the poet's own painting.

———. *A Brief History of Imbecility: Poetry and Prose of Takamura Kōtarō*. Honolulu: University of Hawaii Press, 1992. Includes more than half of the "Chieko poems" and Kōtarō's account, "The Latter Half of Chieko's Life." For a somewhat larger selection that comes with reproduction of Chieko's paper collages (papercuts), see Soichi Furuta, trans., *Chieko's Sky* (Tokyo and New York: Kodansha, 1978).

A Handmaid's Tale: *Sakhi*s, Love, Devotion, and Poetry in Rajput Painting

Aitken, Molly Emma. "Spectatorship and Femininity in Kangra Miniature Painting." In *Representing the Body: Gender Issues in Indian Art*, edited by Vidya Dehejia, pp. 82–101. New Delhi: Kali for Women, 1997. A thought-provoking essay on the construction of the gendered gaze in Kangra paintings, particularly in scenes of the heroine's bath.

Bihari. *The Satasai*. Translated and introduced by K. P. Bahadur. New York and London: Penguin Classics, 1990. The only published translation of Bihari. The Braj verses are transliterated into English, but the translations are unreliable.

Goswamy, B. N., and Eberhard Fischer. *Pahari Masters: Court Painters of Northern India*. Zurich: *Artibus Asiae* and Museum Rietberg, 1992. A definitive study of Pahari Hills painting and their artists, with lush photographs and scholarly information.

Jayadeva. *The Love Song of the Dark Lord: Jayadeva's Gitagovinda*. Edited and translated by Barbara Stoler Miller. New York: Columbia University Press, 1977. A lyrical translation of the poem with a useful introduction.

Schomer, Karine. "Where Have All the Radhas Gone? New Images of Woman in Modern Hindi Poetry." In *The Divine Consort*, edited by John Stratton Hawley and Donna M. Wulff, pp. 89–115. Berkeley, Calif.: Graduate Theological Union, 1986. An essay dealing with the nationalist response to precolonial conceptions of femininity.

Reading Love Imagery on the Indian Temple

Arand, Mulk Raj. *Kama Kala: Some Notes on the Philosophical Basis of Hindu Erotic Sculpture*. Geneva: Nagel, 1963. A volume that considers erotic sculptures in the context of ancient texts, both sacred and secular.

Desai, Devangana. *Erotic Sculpture of India: A Socio-Cultural Study*. New Delhi: Tata-McGraw Hill, 1975. A scholarly survey of the theme across time and space in India.

———. *The Religious Imagery of Khajuraho*. Mumbai: Franco-Indian Research, 1996. An in-depth study of the sacred sculptural program underlying the Lakshmana and Kandariya Mahadeo temples at Khajuraho, with a brief discussion of their erotic imagery.

Donaldson, Thomas E. "Propitious-Apotropaic Eroticism in the Art of Orissa." *Artibus Asiae* 37 (1975): 75–100. An article that examines issues relating to the erotic in temples in the eastern state of Orissa contemporaneous with Khajuraho.

Kampen, Natalie Boymel, ed. *Sexuality in Ancient Art*. Cambridge: Cambridge University Press, 1996. An edited volume of individually authored essays relating to artistic expression of eroticism in varying parts of the world that brings home to the reader the manner in which certain themes and meanings reverberate across cultures.

Meister, Michael W. "Juncture and Conjunction: Punning and Temple Architecture." *Artibus Asiae* 41 (1979): 226–34. A brief but useful analysis of architectural and sculptural punning.

VIDYA DEHEJIA is associate director and chief curator at the Freer Gallery of Art and the Arthur M. Sackler Gallery. She was associate professor in the Department of Art History and Archaeology at Columbia University in New York for many years. She has published widely on the art of India, ranging from early Buddhist narrative sculpture, to Chola bronzes, to the art of British India, with eighteen books and numerous articles to her credit. Her most recent book, *Indian Art* (Phaidon Press, 1997), is intended for the nonspecialist reader.

ANNAPURNA GARIMELLA is a Ph.D. candidate at Columbia University, New York. Her dissertation is concerned with self-sacrifice, memorialization, and gender in medieval South India. She lives in India and the United States.

JOSHUA S. MOSTOW is an associate professor in the Department of Asian Studies at the University of British Columbia, Vancouver. His translation and study of the *One Hundred Poets* and their pictures, *Pictures of the Heart: The Hyakunin Isshu in Word and Image,* was published by the University of Hawaii Press in 1996. It has been named by *Choice* magazine as one of the "Outstanding Academic Books" of 1997.

HIROAKI SATO, who has published Japanese poetry in English translation in two dozen volumes, is at work on an anthology of Japanese women poets fron ancient to modern times. Among his forthcoming books are translations of Mishima Yukio's novel *Silk and Insight* (M.E. Sharpe, 1998) and a selection of five of Mishima's plays (University of Hawaii Press, 1999).

JAN STUART is assistant curator of Chinese art at the Freer Gallery of Art and Arthur M. Sackler Gallery. Among her recent publications are "Calling Back the Ancestor's Shadow: Chinese Ritual and Commemorative Portraits," in *Oriental Art* (vol. 43, no. 3); "Where Chinese Art Stands: A History of Display Pedestals for Rocks," in *Worlds Within Worlds: Chinese Scholars' Rocks* (Harvard University Press, 1977); and catalogue entries on Ming dynasty paintings for *Rings: Five Passions in World Art* (High Museum of Art, 1996). Previous books include *Joined Colors: Decoration and Meaning in Chinese Porcelain* (Arthur M. Sackler Gallery, 1993), coauthored with Louise Cort.